Holbein

# Radu  Boureanu

ABBEY LIBRARY LONDON

olbein

Translated from Romanian as published by
MERIDIANE PUBLISHING HOUSE
Bucharest, 1977
under the original title of
HOLBEIN
by RADU BOUREANU

Translated into English by
FLORIN IONESCU

It is advisable, if not ideal, that a critic wishing to understand, to grasp the dimensions of the work produced by an artist holding a firm place in mankind's consciousness, should approach the artist and his *oeuvre* with a great deal of love, which presupposes a kinship of structure, of spirit and sensitiveness. This statement could, at the same time, be refuted if one thinks that an art critic, or simply a lover of line and colour joined to a writer, may take a trip into the climate or nature of any work of art, into the universe created by any painter, since the analytical instrument can be used for more than one genre, for more than the *oeuvre* of a single artist.

You may favour a certain artistic conception, outlook, school or discipline, and yet maintain your ability accurately to understand the value of artistic creation by any school, from any time, and to form exact value judgments beyond all matter of personal preference, inclination or taste.

I should like to say with Roger Avermaete, who wrote the interesting *Panthéon narquois de l'école flamande*: " I love painting. To the extent of indulging in what betrays it: the images, such as they are, in black-and-white or in colour, which distort, with perfidious insistence, the idea one has formed of certain works; the commentators, who raise between us and the *oeuvre* the screen of their own vision that they think to be final... I love painting, in spite of the specialists."

I do not deem myself a specialist, I do not pretend, in commenting upon the work of Hans Holbein the Younger, to offer a definitive portrait: It has been done, before me, by recognized commentators, aesthetes of great prestige, well versed in the history of world art.

It has been said of Hans Holbein the Younger that next to Albrecht Dürer he is the most typical representative of German art. The truth, however, could be stated differently. Holbein is a world painter of German origin. Something of his personality and specific art could be found in that arduous, almost methodical work, in that rigour revealing a temperamental facet of the German nature. But the ideal of his art had turned, even before 1530, towards an international classicism. A synthesis of Italian grace and Northern temperament, a beautiful form sustained by an uncommon objectiveness, a minute observation of reality and of the individual features, a balance of shapes and a geometric structure of the composition gave his portraiture the value recognized by his contemporaries and an undying universal fame.

The artistic career of Hans Holbein, that part of his *oeuvre* which has placed him for eternity in the Pantheon of painting, was ushered in, so to speak, was brought about by the approach and triumph of Luther's Reformation.

The artist was born towards the end of the fifteenth century at Augsburg, a most prosperous financial, trade and industrial centre. Powerful bankers, such as the Fugger family, were well known for their international connections. The richness of that great city was giving rise to a lively artistic movement. The art of the Italian Renaissance and the humanistic ideas had taken deep roots in the artistic milieu of Augsburg; many German artists — painters and sculptors — were attracted by the artistic substance of the Peninsula. It is amid that favourable atmosphere that Hans Holbein the Younger came into the world, as the second son of the painter, known

in the realm of art — after his son Hans had established his reputation — as Hans Holbein the Elder. The younger Hans served his apprenticeship, together with his brother, Ambrosius, in their father's workshop. We know nothing very exact about young Hans's beginnings in painting. It seems that both he and Ambrosius assisted Holbein the Elder with the execution of works commissioned of him. At any rate, in 1515, when the elder Holbein was working on the *St. Sebastian* retable, Hans Holbein the Younger left Augsburg, either attracted by the great upsurge of printing at Basle, or in the hope of being taken on by some master. It seems that at Basle both brothers were active in the workshop of a painter from Strasbourg, Hans Herbster.

From that time comes the first work signed and dated 1515 by Hans the Younger: a table-top painted in the *trompe l'oeil* technique, with comico-grotesque elements, which can now be seen, worn with the passage of time, in the National Museum at Zurich. The picture decorating it had been commissioned by Hans Baer, the standardbearer of the city of Basle, who fell in the autumn of the same year in the battle of Marignano. Prior to that he had recommended the young artist to his brother-in-law, the burgomaster Jacob Meyer, for whom, as we know, Holbein the Younger painted, a year later the diptych-portrait *Burgomaster Jakob Meyer*, and his Wife, *Dorothea Kannengiesser*.

The great humanist Erasmus of Rotterdam had written his *Praise of Folly* in 1509, at a time when the crisis of Christianity was beginning, when Pope Julius II was uncertainly seated on his pontifical throne, and when Louis XII was striving to convene a Council at Pisa in order to reform the spiritual foundations of the Church. After journeys to Italy and France, Erasmus went to England for the third time, at the invitation of Henry VIII, who had recently ascended the throne. After years of work there, among illustrious friends like Thomas More, he returned to the Continent and began printing his writings at the establishment of Johann Froben, a Basle bookseller. It seems that in that year — 1515 — through the intermediary of the humanist Oswald

Myconius, the Holbein brothers were commissioned to illustrate Froben's edition of Erasmus' *Praise of Folly*.

From that date, and thanks to the impression created by the illustrations, Holbein became known among the humanists and the chief publishers of the day: Froben, Curio, Cratander, Adam Petri, and Jean Bebel decorated their editions of the *Praise* with Hans Holbein's illustrations. But it was much later, in 1521, that the artist met the author.

His genius was recognized from his entry into the realm of art through these superb decorative inventions, which have made him famous down the ages as a fecund, peerless illustrator. It is true that he found much understanding and appreciation with the Basle printers, for the art of printing, which made use of drawings and illustrations, enjoyed a rich tradition there. No doubt, Hans Holbein's brilliant career was due to his genius, to his arduous, unremitting work, chance coming in only in the guise of his way being cleared by the great Erasmus, who gave him letters of recommendation to his English friends, notably to the closest and most influential of them, Thomas More.

Before going abroad — that is, first to Lombardy, in Italy, across the Alps — and while still at Lucerne, Hans Holbein did some remarkable work as a portraitist — painting for the great families of the city — and as a decorator, doing house façades and interiors, such as the frescoes painted for the Hertenstein family, and proving himself an established master of monumental art. That was happening between 1517 and 1519 — a period during which he also took a short trip to Italy. The discovery of Italy had for him almost the same significance as for Dürer. Holbein was enabled to come into direct contact with the works of Leonardo, Mantegna and the artists of the Italian High Renaissance.

In 1519, he returned to Basle and joined the painters' Guild, and the next year he became a citizen of Basle. While working for the printers of the time, Holbein also painted the portrait of the young lawyer and humanist *Bonifacius Amerbach* (1519) and began the first set of frescoes designed to decorate the Great Council Chamber of the Basle Town Hall — which, however, he would finish much later, in 1530. For this fresco, highly appreciated by the Councillors, Holbein received, on starting the work, 120 florins. In the same period, thanks to the appreciation commanded by the great fresco, he was commissioned to paint the exterior of a residential building, the so-called 'House of Dance' *(Zum Tanz)*, which, it seems, he painted in an amazingly beautiful way (the designs have been preserved), its renown becoming legendary with time. I wrote 'it seems' because most of his larger decorative works are lost to us, having been worn out, in part or entirely, by time and the weather.

As regards the religious paintings of Hans Holbein the Younger, one may say that the most representative works had been produced by 1526.

Born between Hieronymus Bosch and Pieter Bruegel, Hans Holbein is different from the sensibility of these two fantasts, moving through medieval spiritual mists, who carried on the echoes of the superstitions and obscure puzzles of that time, and from the German Gothic expressionism of a Schongauer and Grünewald. He avoided the psychological expressive paraphernalia of such an atmosphere, remaining in a state of artistic balance, with a serene, classical vision, if one allows for such exceptions as that *Dead Christ* (1521) and the set of drawings in which the forms and gestures of life are accompanied by the allegorical, skeleton-like, tutelary presence of death. Hans Reinhardt regards Holbein the Younger as a summit of German religious art, but I think that his religious pictures, where he presents the relation between reality and divinity, are rather formal, our satisfaction resulting solely from the artistic perfection, from his technique. Holbein is an objective analyst in the ancient sense. Sometimes

his works betray an Italian influence. *(The Chancellor Hans Oberried* retable, 1521—22, and the *Last Supper* retable, 1522), or the influence of Flemish and Dutch artists *(The Passion)*.

And yet, many of the religious scenes reveal a pronounced detachment from faith and religious meditation, whence Holbein's classification, by some connoisseurs of his art, among the realistic analysts. The phenomenon is patently demonstrated by

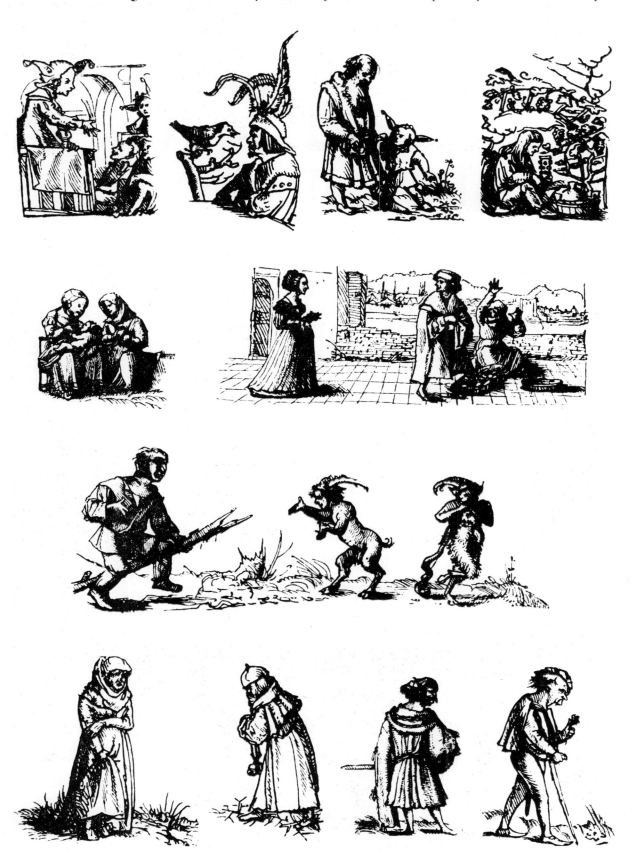

*Marginal drawings for Erasmus'* Praise of Folly

that *Dead Christ*, 1521, where the artist seems to have depicted a corpse, of some drowned man perhaps, with a human expression, bearing all the stigmata, and the face of that man, the stillness of death, show nothing superhuman, none of those marks of divinity that the subject and the character required according to the canons.

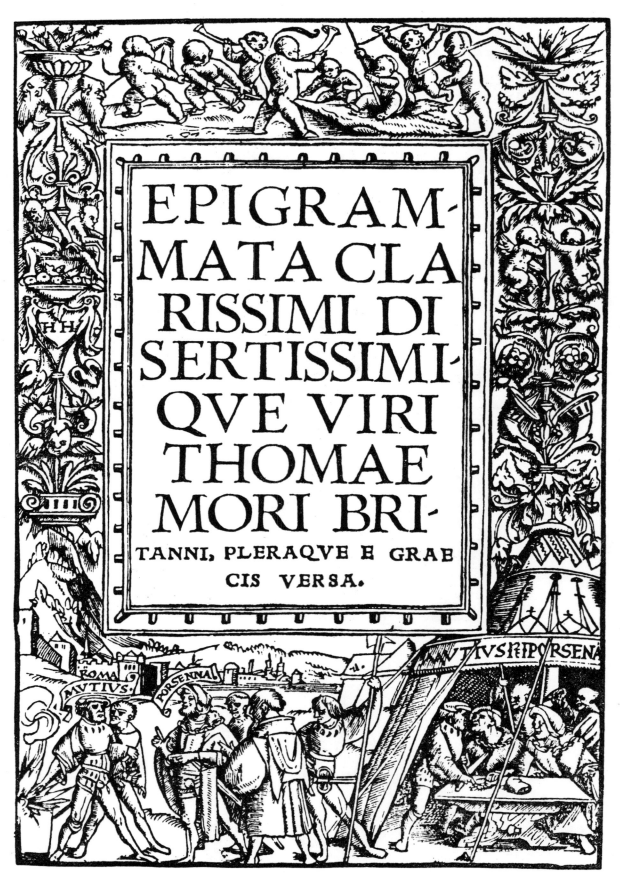

*Title-page for Thomas More's* Epigrammata

The artist's realistic intelligence is obvious, as well as his structural non-acceptance of Christ's divinity.

The mystic spirit and enthusiasm of a Grünewald or El Greco cannot be detected in Holbein's religious pictures. Many scenes in the *Predestination* and *Passion* cycles show a pronounced theatricalism, and the setting of the mystical scene invariably includes recherché and altogether invented interior and architectural elements, reminiscent of a late-period Greek or Roman metropolis. The religious pictures of a Grünewald or El Greco are not fixed in a certain urban setting, as with Holbein; they emerge from an imponderable space, from the dramatic imprecision of nature, shadowed by unfathomable fears and arcana.

There is a woodcut in the Basle museum, *Christ carrying the Cross*, where the bent body and the cross form a beautiful angle, subtly balanced in the image, and the thorn-crowned head expresses weariness, exhaustion and human suffering, reminding one of that line in Panait Cerna's poem *Isus* (Jesus): "Thou wert a man and like a man thou suffer'd." In that image Holbein seems to have expressed his human sympathy with the man Jesus. After years in which the painter's art and vision had been characterized by in-depth observation of man, in portraits and compositions where the human face and body were foremost, Holbein returned to a Christian theme in that incomparable composition, *Noli me tangere*. This canvas of imprecise date, the composition, the balance and rhythm of the figures, the incredible, preternatural mood rendered by the tones and the entire symbolism of the picture contradict Holbein the realist, the logical, even cold author of his other religious pictures, and yet express the analysts, the keen interpreter of the human soul, of the depths of the human face that he sought in the play and conflicts of man's nature.

Holbein had met Erasmus at Basle in 1521, through the intermediary of Myconius, Amerbach and Froben. The spiritual penetration that he noticed in Erasmus roused the artist's curiosity. Although Holbein had done some valuable portraits before this period (1523), his genius as a portraitist revealed itself now, in the two portraits of Erasmus that he painted. The intellectual sovereignty of the scholar, of the unsuccessful monk who had reached the high summit of humanism, the inborn kindness of the man — all is rendered by Holbein through deeply felt lines, shapes and colours. The profile of the humanist scholar is depicted by a psychologist, by a keen observer of the essence, of the human nature. The long, pointed nose, the lips drawn into a bitter-sweet rictus seem to scent, to search for meanings and countermeanings, with that sly, waggish, erudite face of his, eyeing opponents in scholarship with a forgiving, though at times merciless, irony.

In 1526, at a time when the fury of the Reformation against religious paintings had assumed terrible proportions, thereby severely curtailing the livelihood of the artists' guilds in Basle, Jakob Meyer, who headed the Roman Catholic party, commissioned the young Hans Holbein to paint the picture known as *The Virgin with the Family of the Burgomaster Meyer*, where, in a sober architectural setting, the burgomaster and all his family are shown kneeling under the protection of the Virgin and Child.

The artist felt the need to emigrate to an Eldorado that could assure him a decent living and a feeling of full responsibility for his art, an open field for the achievement of his artistic self, of the work he felt able and in duty bound to leave to posterity. The letters of Erasmus, to his friend Thomas More, philosopher and author of *Utopia*, were the credentials that opened for him the gates of England.

In their correspondence with Holbein's protector, the friends of Erasmus, and most of all Thomas More, expressed their concern about what the artist could

expect there. Nevertheless, thanks to the court connections made through these people

and through his excellence as a portraitist, Holbein gained an ever-increasing esteem and clientèle already during his first English period.

The commissions Holbein received during his two years' stay in England, enabled him to buy, on this return home, a house in the St. John district of Basle. He had found his family reduced to poverty. *The Artist's Family* that he painted in that period (1528) is a vivid image of what struck the eye and heart of an unsentimental, realistic painter — a family he had had to leave unprovided for, owing to the vicissitudes of art. The physiognomies of the woman and children, distressed with poverty and with the husband and father's absence, dictated that work of a tragic expression — a human and artistic document.

The political situation, however, was no better in Germany. At Easter in 1529 the City Council was obliged to remove the religious paintings from the churches. The next year, mutinous troops destroyed in the cathedrals the finest works of religious art. Canvases, painted altars and statues were torn down ; hammers and axes broke up the wood carved with the fervour of artistic creation, and smashed the marble, and enamels. Huge fires offered up a large portion of German art to the blind god of heresy.

Holbein still got a few minor commissions. The Basle publishers reduced almost completely the printing of engravings in books they still brought out. The artist was considering another trip to England. Waiting for a new recommendation from Erasmus, he lingered at Antwerp. It seems that his one-time protector had changed his opinion of the artist who had portrayed him. While the great thinker had been living in retirement — because of the circumstances — at Freiburg im Breisgau, Holbein visited him several times and depicted the ageing scholar in a new series of portraits.

Writing to Bonifacius Amerbach, a refined man of culture (whom Holbein has immortalized in a famous portrait), Erasmus reveals his new attitude to the painter he appreciated several years back: "Holbein," he says, "has wrung a letter of recommendation for England out of me, and thanks to you, but he stayed at Antwerp a full month and would have stayed even longer, had he found a pretext. In England he disappointed those to whom he was recommended." No one knows what caused the great scholar's dissatisfaction — says the historiographer. Was he in opposition to the artist's difficult character? Or did he think that Holbein had not idealized him enough in those portraits, which revealed the unmistakable marks of time?

Yet, before the end of 1533, Hans Holbein was in London again.

Here, however, the social picture had changed during his absence. Archbishop Warham had passed away. Thomas More, removed from his office as Lord Chancellor, was living a secluded life in the countryside. The artist's main English protectors with the Court and the nobility were no longer there, to help him again in the favour of London's high society. But Holbein managed to form new connections among the German merchants, and portrayed several German merchants, members of the Steelyard guild — the London trading agency of the Hanseatic League. He also decorated the hall of the guild with two large-sized compositions, *The Triumph of Riches* and *The Triumph of Poverty*.

Little by little, his artistic vigour, his genius and his growing prestige won him the regard of the nobility. Portraits of courtiers, of ambassadors sent by Francis I to Henry VIII's court, pointed him out to the King himself.

In turn, Holbein portrayed the infortunate queens: Anne Boleyn (1533), beheaded in the Tower of London; Jane Seymour (1536) who died prematurely after the birth of Prince Edward; and such would-be ones as the young widow of Duke Francesco Mario Sforza of Milan, Christina (1538) daughter of the King of Denmark. During a short stay in Basle, where the artist went to see his family, the townspeople had before them a quite different Holbein from the one they knew. Richly dressed,

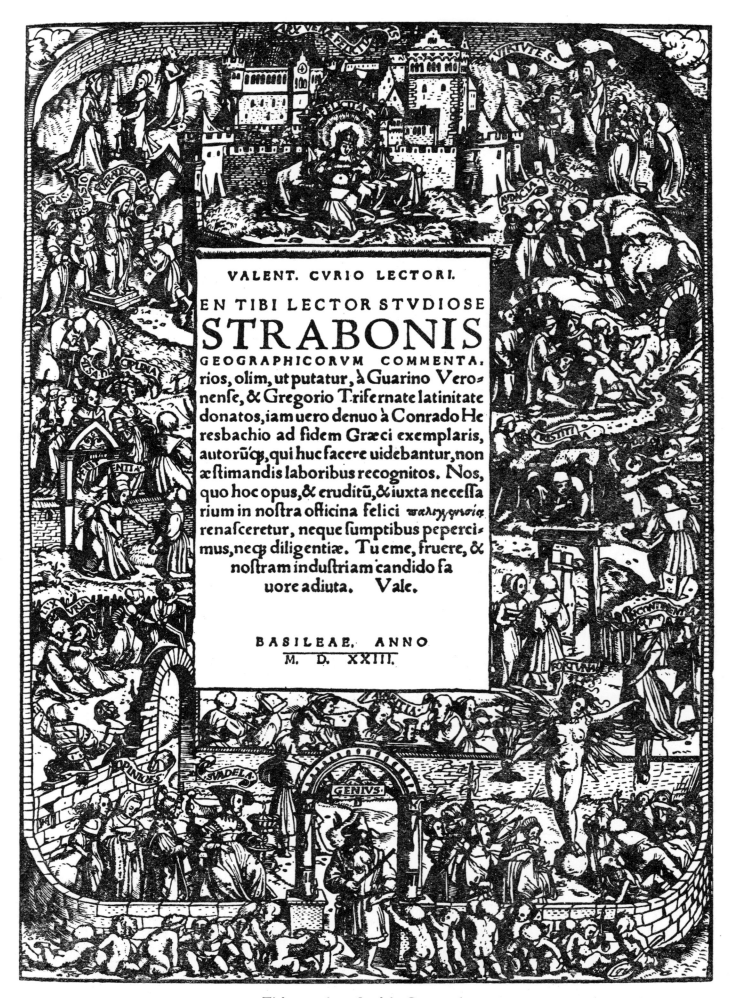

VALENT. CVRIO LECTORI.

EN TIBI LECTOR STVDIOSE
STRABONIS
GEOGRAPHICORVM COMMENTA-
rios, olim, ut putatur, à Guarino Vero-
nenfe, & Gregorio Trifernate latinitate
donatos, iam uero denuo à Conrado He
resbachio ad fidem Græci exemplaris,
autorṹq́, qui huc facere uidebantur, non
æftimandis laboribus recognitos. Nos,
quo hoc opus, & eruditũ, & iuxta neceffa
rium in noftra officina felici παλιγγενεσία
renafceretur, neque fumptibus peperci-
mus, neç̃ diligentiæ. Tu eme, fruere, &
noftram induftriam candido fa
uore adiuta.    Vale.

BASILEAE. ANNO
M.  D.  XXIII.

Title-page from Strabo's Geography

with the airs of a great seignior, casting critical glances at the work he had done at Basle, and considering that he could remake and make consummate pictures, he was asked by the City Council to work for the city. He did not stay long at Basle, and returned to England on October 16 of that year, via Paris, where he remained till the winter, when he left for London.

Now Holbein was an artist-ambassador again, with the task of portraying the princesses considered for marriage to the terrible king of England. The English monarch thought it advisable to have closer ties with the Protestant German princes. Holbein painted Duchess Anne of Clèves in the castle of Düren (1539).

As far we know, landscape and group life are very rare in his *oeuvre* during that time. He was a keen realistic observer of the portrait, of the psychological portrait; a painter of the bourgeoisie and, through his connections, of the nobility, of monarchs, a Court painter.

We know very little about this traveller through the world and the human being. He has left no notes. He never recounted his life, never voiced his thoughts or his credo. These are seen in his lines and colours, in his great passion for the image of man. Driven out of Augsburg, out of his native Bavaria, by religious fanaticism, by the Reformation, which destroyed the values created by the artists of the time, he died, in the full maturity of his artistic talent, killed by the plague raging in London in the year 1543.

Holbein's *oeuvre*, ample in scope and variety, has been partly lost in the vicissitudes of history, and we can only reconstruct it from fragments, from those of the artist's plans which have been saved for posterity.

As mentioned above, his genius as an author of monumental decoration is revealed to us by a few intact works.

In the Renaissance style, vast mural spaces came to life through Holbein's brush and palette — legendary worlds, mythological gestures, scenes with moralizing social and historical subjects. The more valuable they were since beyond their precise purpose as civic and human teachings, they lived through their expression, through their colour and rhythm.

The history of world art testifies to the immense creative strength and inexhaustible staying power neaded for the physical work put into the frescoes, the vast compositions, of a Michelangelo or a Ghirlandaio — and Hans Holbein the Younger is reported to have possessed them. Quite telling is the image we know from his self-portraits, where a determined head of great vitality confirms the vision of Holbein's twofold force — his genius and the strength of his human fibre.

A forceful technique, a skilful composition and an intense expression place him at the same level of fulfilment with the most renowned — the equal of many an artistic genius.

Holbein's portraits make up a wonderful collection of types and characters, adding to the style, atmosphere and psychology of the time, the race, mentality and inward traits of a nation, for these faces are different, they bear a particular national stamp, German, French, English, or Flemish.

We readily notice the thrifty, amiable bourgeois expression in the *Portrait of Burgomaster Jakob Meyer* (1516), or the stodgy and, at the same time, effeminate face in the *Portrait of Benedikt von Hertenstein* (1517) with lips and a smile reminiscent of a gossipy German woman, or the romantic German face of *Bonifacius Amerbach* (1519), the man whose culture and subtle thinking were highly valued by Erasmus. Those who have seen the picture will testify that it is a work of intense feeling and rare depth.

In general, Holbein's portraits, perfect in style and technique, are characterized by a restrained lyricism, by a cool nobleness, by an unmerciful psychological depth.

I should try now to point out what is, in my opinion, the novelty, the nuance bringing Holbein closer to a rather modern understanding of the portrait, namely a simplified interpretation of the portrait in terms of draughtsmanship, a search for the sitter's inner soul, with a pure, stylized line rendering the ideal features of the face.

First of all I should like, however, to recall that piece in the series of portraits Holbein made of Erasmus, the one in the Louvre, or the portrait of *Robert Cheseman*, King Henry VIII's falconer.

The *Portrait of Erasmus* (1523), the small portrait painted on wood, is the finest, the most marked by the stamp of a double genius — the illustrious model and the artist. Looking at this portrait, one is captivated by the sober palette, the grave yet warm tones, the precise, simple yet stylized line of the design, by the balance, the agreement between the decorative background, with stylized, rhythmic floral and animal elements, and the calm expression of the face, or the browns with greenish reflexes and the burned-brick red of the coat.

The *Portrait of Robert Cheseman* (1533) — with its rhythmic purple parallels breaking through the deep, matt black mass of the coat warmed by the brown of the fur collar — is likewise magnificently drawn, displaying again the artist's excellency in modelling forms, in rendering the virile though reflective tone of the face, in reaching a perfect harmony of form and colour. As in most of Holbein's portraits, the inner world of the sitters is seen mainly through the eyes, through the look. Even in the preparatory drawings for the portraits, such as those of the Duc and Duchesse de Berry (1524), or of many others, no matter how summarily outlined, the faces begin to live, notably by the expression of the eyes, by the smile or the grave, tragical rictus, heralding the fulfilment of the future work, of the painted portrait, of Holbein's portraits — masterpieces of unparalleled objectivity, seduction and brilliance of execution. In his portraits Holbein depicts the determinate and the indeterminate facets of human nature. Seeing and painting, he undertakes a journey of the spirit, of sensibility, into the inner human tree of the sitter, of the person before him, whose being and soul he penetrates in order to bring onto the canvas the depths and meanders of that man's personality. As for the contruction of the picture, Holbein never exaggerates, nor simplifies, but renders, with a keen realism, what the models show him, plus the vibration of colour, the draping of the clothes, until the non-living matter fuses with the living, with the shapes, with the very being of the model.

Years ago I was admiring Holbein's paintings in the National Gallery of London: the portrait of Princess *Christina of Denmark, Duchess of Milan* (1538) and the large picture representing *The Ambassadors*. In addition to the austere palette with which the first is rendered, in addition to the grave beauty, the interiorized face, the heavy, material yet elegant draping of the coat, with dark garnet reflexes, the deep, dull green background, with the upright shade on the right-hand side of the picture, which is remarkable for its realism, and simple, laconic construction, that of the *Ambassadors* captivates one, in its turn, by its balanced composition and natural attitudes, by the expression on those faces, and by the perfect art of decoration, without stressing the decorative element of the drapery, of the cloth covering the high table where we see two exceptional still-life tiers. At the bottom of the picture is a strange element, apparently foreign to the composition, a kind of fossil, a large bone from some prehistoric beast, lying diagonally. An explanatory text to the right of the picture tells the visitor that the thing is the distorted image of a human skull, rendered in perspective. When viewed frontally, the skull is indiscernible; it shows its real shape only when seen from

16

a certain place (to the right of the picture). The inclusion of this skull by Hans Holbein may have the meaning of a *memento mori* (remember that you must die!). The artist thus opposes the skull to the rest of the picture, painted in a warm range of colours and leaving a general impression of vitality.

To this versatile painter and draughtsman, to the author of the *Dance of Death* (1524—1526) and of so many other engravings destined to illustrate the *Hortulus animae* (The Garden of the Heart), the skeleton-like symbol of Death as a character is if not an obsession, then the materialized presence of the final element. This skull, added to the *Ambassadors*, marks the artist's consistent vision of the frailty of human destiny.

*Battle of Lansquenets*

In the *Portrait of Georg Gieze*, painted by Holbein in 1532, the objects making up still lives are abundent, but grouped with a pronounced sense of dosage and rhythm, revealing, beyond the sumptuous portrayal, an interest in the human face and in the personal traits of the sitter.

One of the most impresive portraits done by Hans Holbein seems to be, as some art historians hold, that of *Charles Solier, Sieur de Morette* (1534). By the rendering of personality, by its majestic soberness, by its grave colouring and depth of interpretation it surpasses that of King Henry VIII.

With the portraits done while Holbein was a court painter there comes about a change in the artist's vision and palette. The dark tones and the deep-green backgrounds now take on lighter shades. Possibly aware of the sombre, psychologically unstable atmosphere at the Court, Holbein resorts to a more lily-like light, if only of a formal purity. The grounds brighten up with blue tones and nuances. His decorator's skill impels him to render, as often as possible, a feeling of splendour, seeking most realistically to reproduce the gorgeous clothing, the necklaces, the gems sewn into the costumes, the colours. And yet the colours, no matter how carefully rendered, are not merely dead matter. A passion for light and colour as such comes out through the material shapes. There is an osmosis here, a necessary sensitive link

17

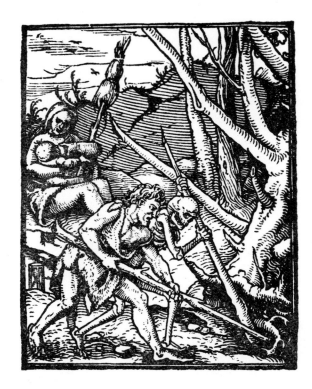

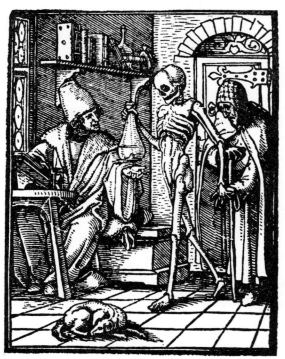

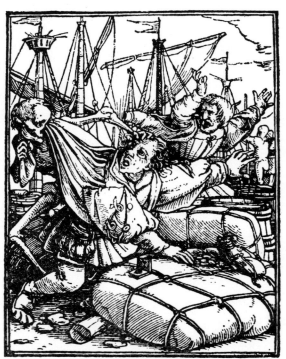

between the heavy clothes, and stones, and gold — and the human expression in the portraits.

The decoration of the costumes, the rich gems and jewels never leave an impression of overloading, of excess, of superfluous, obsessive detail; they blend with the entire structure of the characters, of the bodies, of the human physical presence, which is never crushed under these accessories. Let us take, for instance, the great Portrait of *Henry VIII* (1536), that King of such variable temper, cultured, intelligent, ruling by persuasion, domineering, at times resorting to terror, violent, friendly to the arts. All the apparel covering the ponderous body of the hotblooded monarch cannot weigh down, hide, dissimulate his character, the psychology of that huge, unappeased body — a fiery biological phenomenon. The square face of the sanguinary Henry, bears an expression of exceptional vitality, the suppressed cruelty of an acid, strained, barely

formed smile, trying to look courteous and humane. The hands, as Holbein saw and depicted them, lie heavy on the belt and dagger, like two strange, disquieting creatures, which stare alarmingly, through the garnet stones of the rings (two blood-red eyes!) at the future victims.

In Holbein's portraits every detail is observed and naturally added to the general design, without impairing the harmony of the whole. A certain sophistication and fashionable taste is to be noticed in his art too, as in that of some Renaissance Italians, but Holbein's *oeuvre* is not depreciated by such pictorial accessories. Holbein remains a vigorous, realistic painter and portraitist, sensitive, never seeking to alter the essential, natural human features of the model. He never idealized; he lucidly interpreted and rendered the line and colour dictated by the object, by the subject, by what he actually saw.

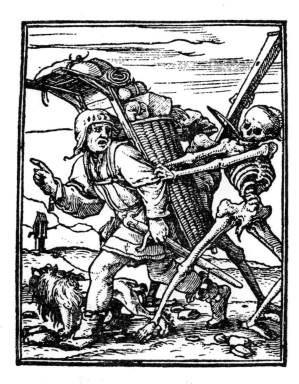
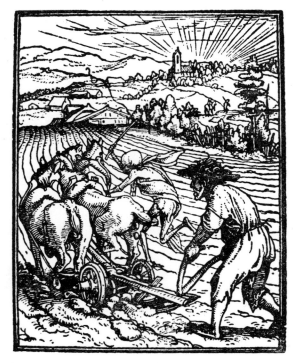
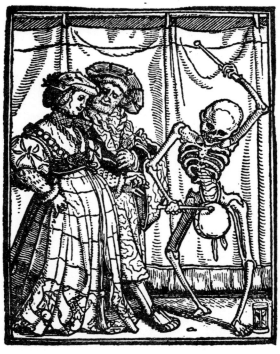
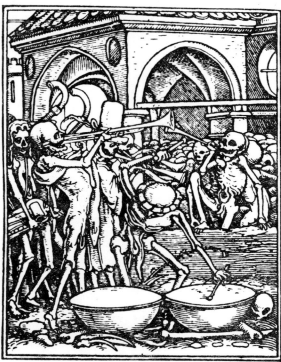

Hans Reinhardt, of Basle University, rightly said in 1958 that "thanks to the artist's objectiveness, and to his gifted eye and intuition, one could see in Holbein's portraits the differences of social status, nationality and thinking reflected upon the faces." The limpid genius of Erasmus was read from his features, as was the mediocrity of a Gisze, the qualities of Kratzer, or the spiritual nobility of a Sieur de Morette. The portrait thus becomes a mirror of the traditions, moral traits and culture of an entire historical period.

Beyond the value and masterliness of the colour portraits and of the famous works on a show in the world's museums, there emerges Holbein the draughtsman. His portrait drawings, either preparatory for the future painted portraits, or mere sketches in charcoal, or in pencil with crayon additions, are in themselves masterpieces of searching for and rendering the human substance, which the artist follows with unparalleled grace and gusto. His drawings seem to be questions about the depths of human nature. Carefully executed, with a permanent check on fantasy, the hand acting as a seismograph which, through the finger-tips, backed up the penetration of the artist's eyes.

Holbein's drawing is magical, the fruit of probings done through a kind of special sense, where his keen eye lost the track. And it hardly ever lost it.

Holbein learned to draw in the *trois crayons* manner in France. He perfected this technique in England, bringing it to a high standard of subtlety and refinement in such drawings as those of Anne Boleyn, Jane Seymour and Theophrastus von Hohenheim, and in a long series of works presaging the modern style of drawing.

Some four hundred drawings and studies have been preserved — a valuable, indispensable documentary source on the life and work of Hans Holbein.

It is inexplicable that some exegetes of Holbein's art did not notice that in his various types, in his portraits and compositions, the artist deciphers and translates the human hieroglyph of each model. It is quite clear that, intuitively, Holbein 'read' the sensibility of each one, that he got at the key opening the most secret look to the unique expression of the being.

It has been said that Holbein is no poet, that he is never obsessed with theorems, that he has no philosophical background. Yet Holbein does have, in his artistic structure, the gift of analysis. While looking at his subject, that is at the model, he dissects it, he goes into the depth of the human being; he possesses that science, the realistic metaphysics that enable him intuitively to detect in each sitter the ontological modes of the individual, or, often by axiom and deduction, the primary notions which help him to read that *de internibus* of the person he is viewing and portraying.

In fact, if one looks at Dürer's and Holbein's portraits of Erasmus, one cannot fail to notice the difference between these artists' peculiar modes of seeing and depicting. Erasmus is depicted by Dürer in a very sensitive drawing, then in a more official copper engraving dated 1526, with that outward expression of philosophical gravity, rather than with one of illumination, of returning into his own mental universe through the meanders of his spirit — analytic, ironic, disparagingly critical of certain harmful forms and concepts, of certain fanatic spirits and categories of his time.

It is true that Dürer expresses, in his vast *oeuvre*, an artistic synthesis of the philosophical thought of the Middle Ages, of that strangely poetic fifteenth century.

The compositional structure of Dürer's paintings, drawings and engravings is imbued with a subtle load of poetic sensibility. With Hans Holbein everything is packed into a sober, economical expression; the line defines, explains, concentrates. Albrecht Dürer has the grace of an amazing calligraphy, which is never a load, but a sensitizing vibration; with Holbein, though, one is struck by the compression of feeling into the texture of very precise lines, yet not from a paucity of expression but, on the

contrary, helping to intensity it. The concise, penetrating ductus is evocative of the form, and it clarifies the compositional vision.

We have not sufficient elements, sufficient written materials, from Holbein or from others. The commentators of his work deplore this gap in the chronicle of his life. Those tending or attempting to construct must draw upon their own imagination. Some of them have already done so. But who can get near enough the unfathomable dimensions of Holbein's real life, with its setbacks and disappointments, its joys and its passing successes? No doubt, a life of hard, unremitting work, full of anguish. The anguish of self-definition, of endless, feverish search for a peculiar road in art, at the crossroads of social and historical adversities, like the Reformation, which affected many fields of life and morality. And then the plague, in the wake of the Reformation, taking away lives, among them that of his own daughter, Annele, killed him too, in London, at a time when his glory was undeniable.

No doubt, like many great artists of all times, Holbein was, if not tormented and beset, then at least occasionnally haunted by some modern or metaphysical thoughts and questions about existence and art. His thoughts and questions about existence took material shape in the famous cycle of the *Dance of Death* (1524—26), which is a representation, not formal, not literary, but of a remarkable cold materialization of his feeling and attitude towards the last guide of man's passing from being into non-being. What is the genesis of wood-cuts ranking with the world's finest works of art? Is it due to a suggestion from Erasmus of Rotterdam, who wanted to write a text on this theme, to be illustrated by Holbein? Or to a contract signed with the publisher Trechsel?

In this set of engravings, in the oft-repeated final scene of the meeting with Death, the line is cool and precise when depicting the symbols and representations of various human states and categories. And quite strangely, Holbein does not seem to be frightened, terrified by the subject. In his works he frequently portrays images of this phenomenon, which is not macabre to him, but a logical conclusion, the fruit of ascertained facts: an unavoidable ultimate condition, which he seems to see and point out to people in every walk of life, bearing the marks of their habits and positions, and not realizing that eventually they must relinquish them.

Holbein seems to be smiling, rather than grinning, when he depicts the movements of the *Dance*, not a dance of death, but the last steps taken, willy-nilly, by those represented as they would not be—faced with an irreversible condition. The Bishop, the Usurer, the Coquette, the Physician, the helpless Old Man, the Child, the Ploughman, the Merchant, the Rich Man, the Seaman, the Lady, starting with that vision of damned Adam tilling the land. All are accompanied by the skeleton-like personification of Death, whom Holbein chooses to accept rather than oppose or dispute with. He allows the movement to develop freely, naturally, fatally, for it does not frighten him. This is not the symbolic representation found on the walls of so many cathedrals and monasteries painted there to terrify, but a cool vision of death, a natural, inescapable end, a term to and a payment for the agitation and happiness of life, avidly sought and experienced even by those who so often insincerely invoke the unwelcome last attendant of the *Dance of Death*.

The aesthetic rules laid down prior to his time may have been considered by him, then adopted or rejected, some becoming an integral part of his structure, of his views, while others he felt to be obsolete or contrary to his own ideals and temperament.

Evincing a keen interest in form and portraying observation, his art tends to assume an international character. Holbein is akin to the artists of the Italian classic tradition and can be claimed by the German artistic Pantheon only by virtue of his forced Germanic temperament. His art, with its clear, objective vision, rising — especially in the portraits — as high as the classical forms, is a splendid illustration of humanism. Holbein's canvasses and drawings speak of the people he dissected with the scalpel of his curiosity and intuition, immortalizing them with his vigorous, brilliant brush.

# CHRONOLOGY

**1497—1498** Hans Holbein the Younger is born at Augsburg, the second son of the painter Hans Holbein the Elder.

**1515** Leaves Augsburg with his brother, Ambrosius, going to Basle, where he enters the workshop of Hans Herbster. The publisher Johan Froben prints the first title-page drawn by Holbein. Is active doing typographic ornaments, frontispieces, title-pages and, with Ambrosius, a set of eighty-three marginal drawings for Erasmus's *Praise of Folly*.

**1516** Reaches the humanist circles of Basle, through Myconius and Johann Froben. Paints the diptych-portrait *The Burgomaster Jakob Meyer and Dorothea Kannengisser*, the first work to reveal the talent of the future portraitist.

**1517—1519** At Lucerne, where he paints major mural decorations in the house of Burgomaster Jakob von Hertenstein.

**1518** During the winter, Holbein goes on a short trip to Italy — to Milan and, perhaps, Mantua — where he can see works by the Italian High Renaissance masters.

**1519** Returns to Basle. Ever more commissions and successes. Executed book illustrations, wall decorations and stained-glass designs.
Marries Elsbeth Schmid. On 25 September is admitted to the "Basle Painters' Guild". Paints the *Portrait of Bonifacius Amerbach*.

**1520—1922** Draws in ink ten *Passion* scenes as designs for stained-glass windows. Commissioned to paint a number of portraits, wall decorations and religious pictures — the *Chancellor Hans Obberied* retable, of which only the wings with the *Birth of the Virgin* and the *Adoration of the Magi* have been preserved (Freiburg Cathedral).

**1521** The City Council commissions him to paint a set of frescoes with scenes from the Old Testament and from ancient history, for the Great Council Chamber of the Basle Town Hall. Paints *Dead Christ*. Meets Erasmus, through the intermediary of Myconius, Amerbach and Froben.

**1522** Holbein is commissioned by Hans Gerster to paint the *Virgin between Two Saints*, known as the *Solothurn Madonna*.

**1523—1524** Paints three portraits of Erasmus — now at Longford Castle, the Louvre and Basle, respectively — and numerous stained-glass designs.

**1524** Journeys to France. In Lyons he sees the works of Jean Clouet, and at the Bourges Cathedral he makes drawings after the funerary statues of the *Duc and Duchesse* de Berry.

*Death of Hans Holbein the Elder*

**1524—1526** Draws, for Lyons printers, the cycles with *Icones historiarum Veteris Testamenti*, the *Dance of Death* and the *Alphabet of Death*, which were engraved by Hans Lützelburger.

**1525** A peasant rising breaks out in southern Germany. At Christmas, in Basle, destruction of icons in the churches begins on the spur of the Reformation.

**1526** Portraits of Dorothea von Offenburg as *Laïs of Corinth* and *Venus*. Commissioned by Jakob Meyer to paint the *Virgin with the Family of the Burgomaster Jakob Meyer*, which he will touch up in 1528—29.
The economic crisis, misery and famine make him leave Basle. Provided with letters of recommendation from Erasmus to Petrus Aegidius and Thomas More, leaves for Antwerp and London. In Antwerp he meets Quintin Massys (Metsys), and in London he is welcomed by Thomas More and his friends. In Chelsea, Holbein paints a family portrait for Thomas More, in tempera on canvas (now lost). One can form an idea of it only from the individual preparatory drawings kept in Windsor Castle and from a pen-and-ink sketch of the whole work, now in Basle.

1527—1528 Introduced by Thomas More into the humanistic milieu of London, Holbein paints the *Portrait* of the *Archbishop of Canterbury, William Warham* (Lambeth Palace), the *Portrait of Nicholas Kratzer*, astronomer to King Henry VIII (the Louvre), the *Portrait of Sir Henry Guildford* (Windsor Castle), the *Portrait of Sir Thomas Godsalve and his Son.*

1528 Returns to Basle, where on 28 August he buys a house in the St. John district. The City Council asks him to resume work at the frescoes begun at the Town Hall in 1521. Paints, in all probability, the wings of the great organ of the Basle Cathedral. Upon request he decorates with frescoes (profane art) the homes of various Basle citizens: *Zum Tanz* and *Zum Kaiserstuhl.*

1529—1530 In the spirit of the Reformation, then prevalent in Basle, religious works are torn off from the churches and cathedral. The rebels destroy the most valuable productions of religious art. Holbein receives only minor commissions. He finishes work on the fresco in the Great Council Chamber of the Basle Town Hall.

1531 Decorates a tower-clock in the city. Designs patterns for goldsmiths, jewellers, glassmakers. Designs costumes for Basle ladies.

1532 Leaves Basle again and visits Erasmus at Freiburg im Breisgau, asking him for new letters of recommendation for England. In London, most of his influential friends had fallen into disfavour or had been beheaded. This time he gets commissions from the German merchants at the Steelyard (the London trading office of the Hanseatic League), the hall of which he decorates with the *Triumph of Riches* and the *Triumph of Poverty* — works reminiscent of Mantegna's Triumphs. Among his sitters are Wedigh, Born, Dirk Tybis and Gisze.

1533—1534 Paints the *Portrait of Francis I's Ambassadors to the Court of Henry VIII, Jean de Dinteville and Georges de Selve*, which brings him to the notice of the English Court, and begins a series of portraits of the Royal Household members: the *Portrait of Robert Cheseman*, falconer of King Henry VIII, the *Portrait of Sir Nicholas Carew*, shield-bearer of the King, the *Portrait of Sir Thomas Cromwell*, Chancellor of the King, the *Portrait of Anne Boleyn*, and the Portrait of the *Sieur de Morette.*

1535 *Thomas More and John Fisher are beheaded.*
1536 *Anne Boleyn is beheaded.*

Besides portraits, Holbein makes patterns for goldsmiths jewellers and weavers.
1536—38 Becomes a Court painter, the favourite painter of King Henry VIII.
In 1536 he paints the first *Portrait of Henry VIII* (Lugano, Thyssen Coll.) and several wall paintings in Whitehall, representing King Henry VIII, his father — King Henry VII, and their wives (a fragment is preserved at Chatsworth).

1537 *Death of Jane Seymour, the third wife of the King.*

1538 In March Holbein is in Brussels, where he paints the portrait of Christina, the daughter of the king of Denmark, and at Düren, where he makes the portraits of the daughter of the Duke of Clèves.
In September — at Basle.
Lyons publishers print the first complete series of drawings for *Icones historiarum Veteris Testamenti* and for the *Dance of Death.*
Returns to London via Paris.

1539—42 Diplomatic missions. Paints mainly portraits (studies, drawings, miniatures, and oil paintings), among them those of Anne of Clèves, Catherine Howard, Lady Vaux; his attention is focussed mainly on the human face, the background becoming neutral.

1543 *The plague rages in London.*

On 7 October Holbein draws up his will.

# LIST OF REPRODUCTIONS

**In the text:**

Marginal drawings for Erasmus' *PRAISE OF FOLLY*
wood-cuts from pen-and-ink drawings
1515

Title-page for Thomas More's *EPIGRAMMATA*
wood-cut from pen-and-ink drawing
1518
Kupferstichkabinett, Kunstsammlung, Basle

*ICONES HISTORIARUM VETERIS TESTAMENTI*
wood-cuts from pen-and-ink drawing
Title-page for Strabo's *GEOGRAPHY*
wood-cut from pen-and-ink drawing
1523

*DANCE OF DEATH*
wood-cut from pen-and-ink drawing
1524

*BATTLE OF LANSQUENETS*
Engraving by Ed. Lièvre from wash Drawing
Kupferstichkabinett, Kunstsammlung, Basle

**Plates:**

1. SELF-PORTRAIT (presumed)
Black chalk, colour crayons and water-colour on paper
1538—1540
Kupferstichkabinett, Kunstsammlung, Basle
2. Hans Holbein the Elder
*Altarpiece for the Monastery of Kaisheim*
ADORATION OF THE MAGI
oil on wood
1502
Alte Pinakothek, Munich
3. ST. JOHN THE EVANGELIST
Oil on wood
1515
Kunstmuseum, Basle

4. THE VIRGIN
Oil on wood
1514
Kunstmuseum, Basle
5. PORTRAIT OF A MAN
Oil on wood
Kupferstichkabinett, Kunstsammlung, Basle
6. THE PROCESSION TO CALVARY
wood-cut
Kupferstichkabinett, Kunstsammlung, Basle
7. SELF-PORTRAIT (presumed)
engraved from coloured chalk drawing
1524
Kupferstichkabinett, Kunstsammlung, Basle
8. PORTRAIT OF BONIFACIUS AMERBACH
Oil on wood
1519
Kunstmuseum, Basle
9—13. PASSION OF CHRIST
engraved by Ed. Lièvre from China ink drawing
Kupferstichkabinett, Kunstsammlung, Basle
— FLAGELLATION
Engraving 2
— CHRIST ABUSED BY THE SOLDIERS
Engraving 3
— CHRIST CROWNED WITH THORNS
Engraving 4
— THE PROCESSION TO CALVARY
Engraving 7
— CHRIST BETWEEN THE TWO BANDITS
Engraving 10
14. THE BURGOMASTER JAKOB MEYER ZUM HASEN
Silver-point and red chalk
1515
Kupferstichkabinett, Kunstsammlung, Basle
15. DOROTHEA MEYER KANNENGIESSER
Silver-point and chalk
1515

Kupferstichkabinett, Kunstsammlung, Basle

16. ERASMUS OF ROTTERDAM
Oil on wood
1523
Collection: Earl of Radnor, Salisbury, Longford Castle

17. STUDIES OF HANDS FOR ERASMUS' PORTRAIT
Silver-point
1523
Musée du Louvre, Paris

18. ERASMUS OF ROTTERDAM
Oil on wood
1523
Musée du Louvre, Paris

19. Study for the SOLTHURN MADONNA
(Presumed portrait of Artist's wife)
Silver-point, red chalk and gouache
Musée du Louvre, Paris

20. PORTRAIT OF JOHN ZIMMERMAN
Oil on Wood
1520
Germanisches Nationalmuseum, Nuremberg

21. THE FAMILY OF SIR THOMAS MORE
Pen-and-ink drawing
1527
Kupferstichkabinett, Kunstsammlung, Basle

22. SIR THOMAS MORE
Oil on wood
1527
Collection: Frick, New York

23. CECILY HERON, YOUNGER DAUGHTER OF SIR THOMAS MORE
Coloured chalk on paper
1526—1527
Royal Collection, Windsor Castle, London

24. JOHN MORE THE YOUNGER
Coloured chalk on paper
1526—1527
Royal Collection, Windsor Castle, London

25. SIR JOHN MORE, FATHER OF SIR THOMAS MORE
Coloured chalk on paper
1526—1527
Royal Collection. Windsor Castle, London

26. SIR GREGORY GUILDFORD
Coloured chalk on paper
1527
Royal Collection, Windsor Castle, London

27. WILLIAM WARHAM, ARCHBISHOP OF CANTERBURY
Coloured chalk on paper
c. 1527
Royal Collection, Windsor Castle, London

28. VIRGIN WITH THE FAMILY OF THE BURGOMASTER MEYER
Oil on wood
1526, 1528—1529
Schlossmuseum, Darmstadt

29. LAÏS OF CORINTH
(Portrait of Dorothea von Offenburg)
Oil on wood
1526
Kunstmuseum, Basle

30. MARY, LADY HENEGHAM (?)
Coloured chalk and ink on paper
1526
Royal Collection, Windsor Castle, London

31. SIR THOMAS ELYOT
Coloured chalk and pen-and-ink on paper
c. 1536
Royal Collection, Windsor Castle, London

32. YOUNG MAN IN LARGE SOFT HAT
Coloured chalk on paper
c. 1528
Kupferstichkabinett, Kunstsammlung, Basle

33. ROBERT CHESEMAN
Oil, on wood
1533
Mauritshuis, The Hague

34. SIR RICHARD SOUTHWELL
Coloured chalk and pen-and-ink on paper
1533
Royal Collection, Windsor Castle, London

35. CARDINAL FISHER, BISHOP OF ROCHESTER (?)
Coloured chalk on paper
c. 1528
Royal Collection, Windsor Castle, London

36. UNKNOWN WOMAN
Coloured chalk on paper
c. 1527—1528
Royal Collection, Windsor Castle, London

37. THE ARTIST'S FAMILY
Tempera on paper
1528 or 1529
Kunstmuseum, Basle

38. NICHOLAS KRATZER, ASTRONOMER TO KING HENRY VIII
Oil on wood
1528
Musée du Louvre, Paris

39. LADY JANE LISTER
Coloured chalk on paper
1533—1536
Royal Collection, Windsor Castle, London

40. WILLIAM RESKIMER
Coloured chalk on paper
Royal Collection, Windsor Castle, London

41. SIR JOHN GODSALVE
Coloured chalk, ink and water-colour on

# REPRODUCTIONS

1. Self-Portrait (presumed)

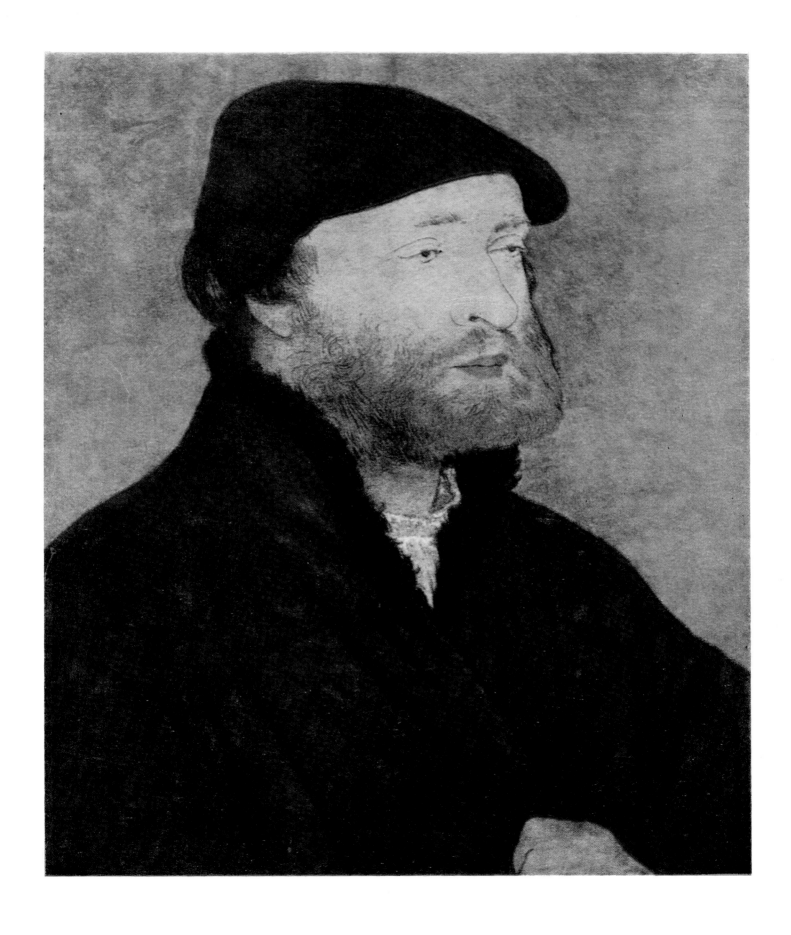

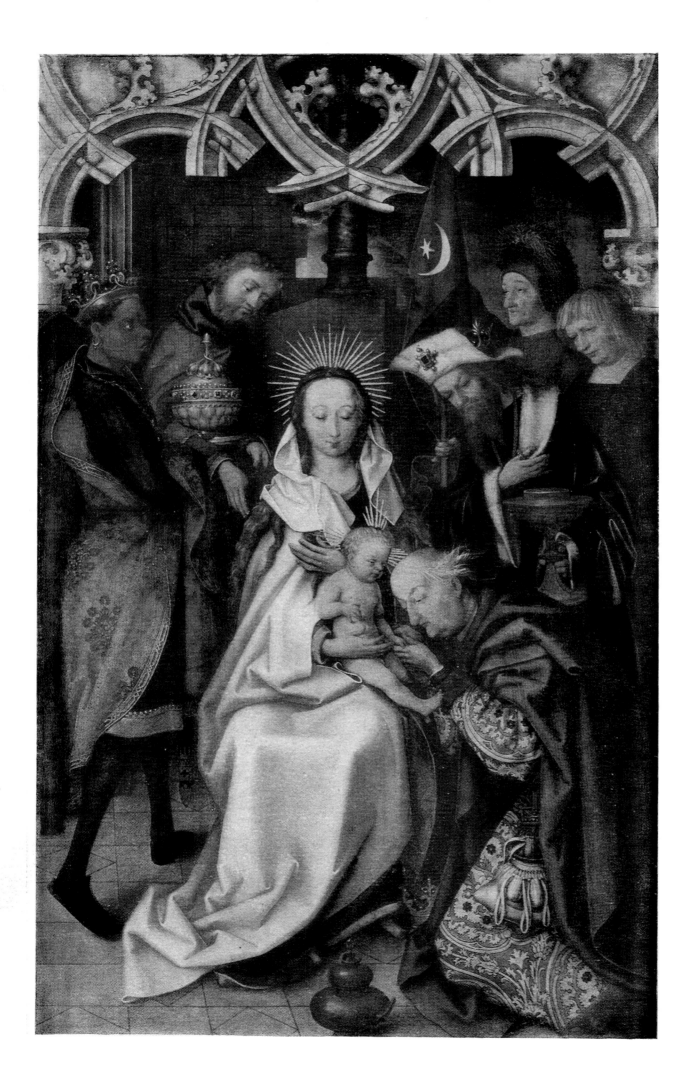

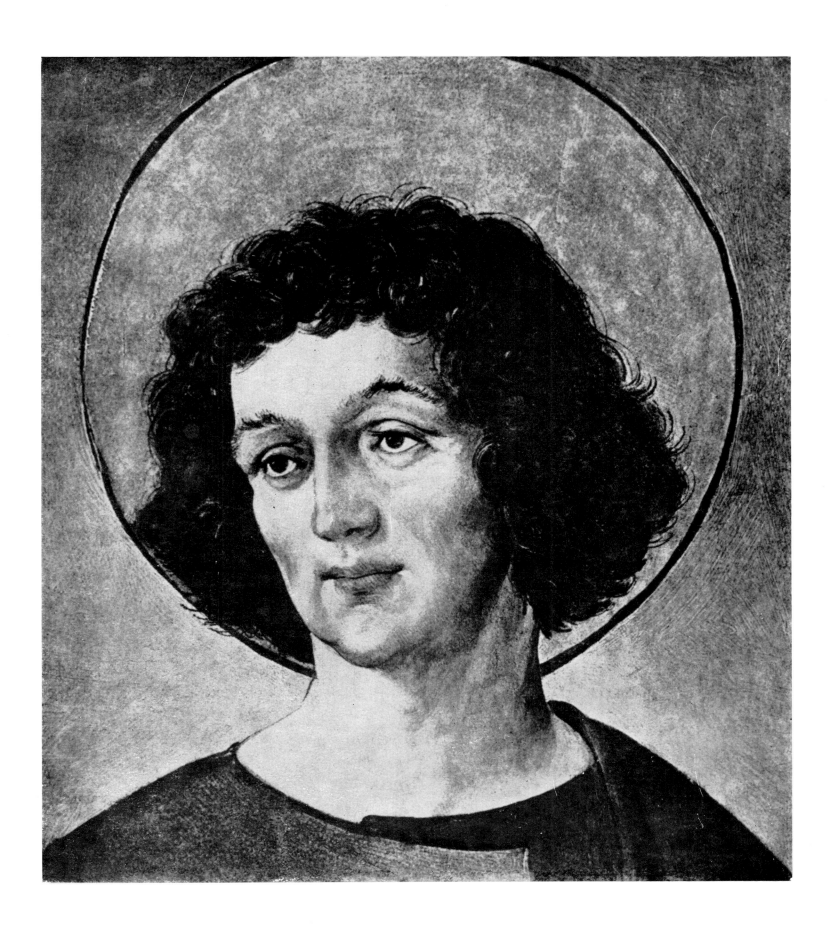

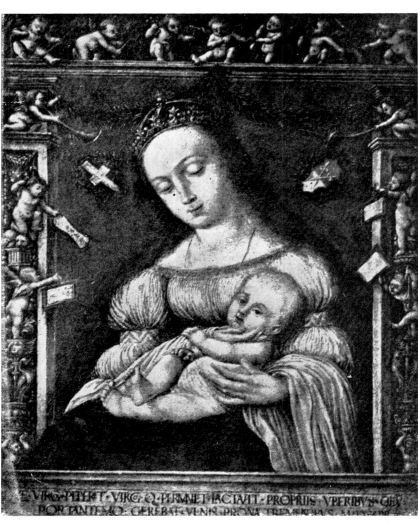

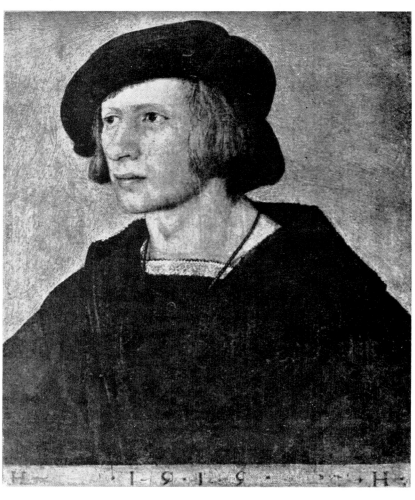

4. The Virgin

5. Portrait of a Man

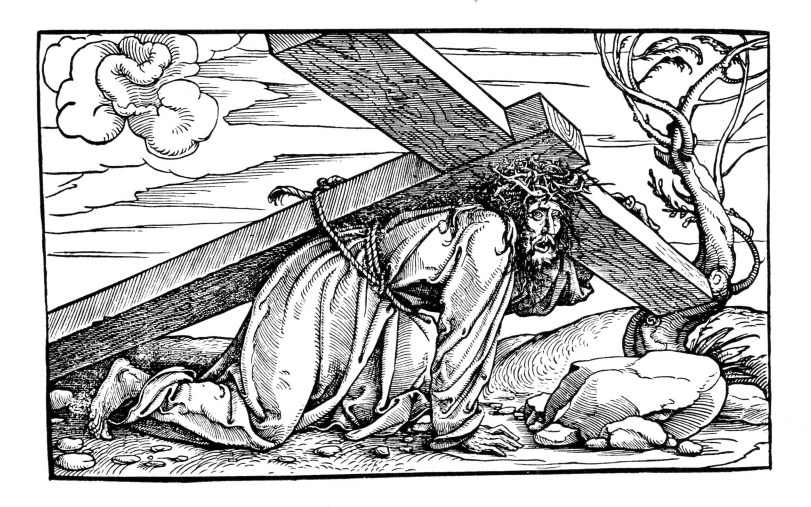

7. Self-Portrait (presumed)

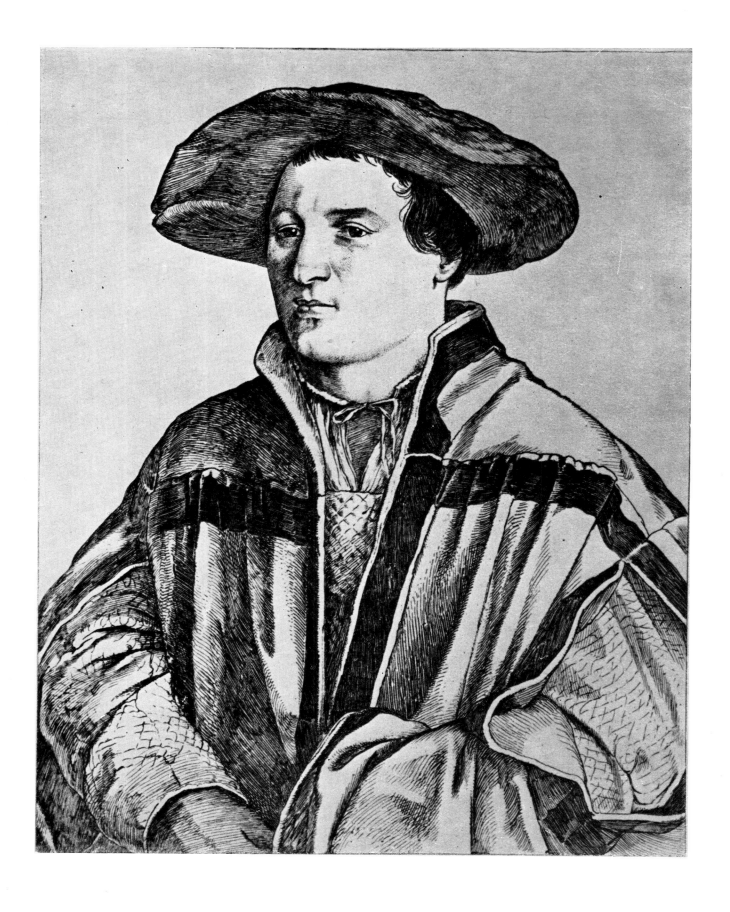

8. Portrait of Bonifacius Amerbach

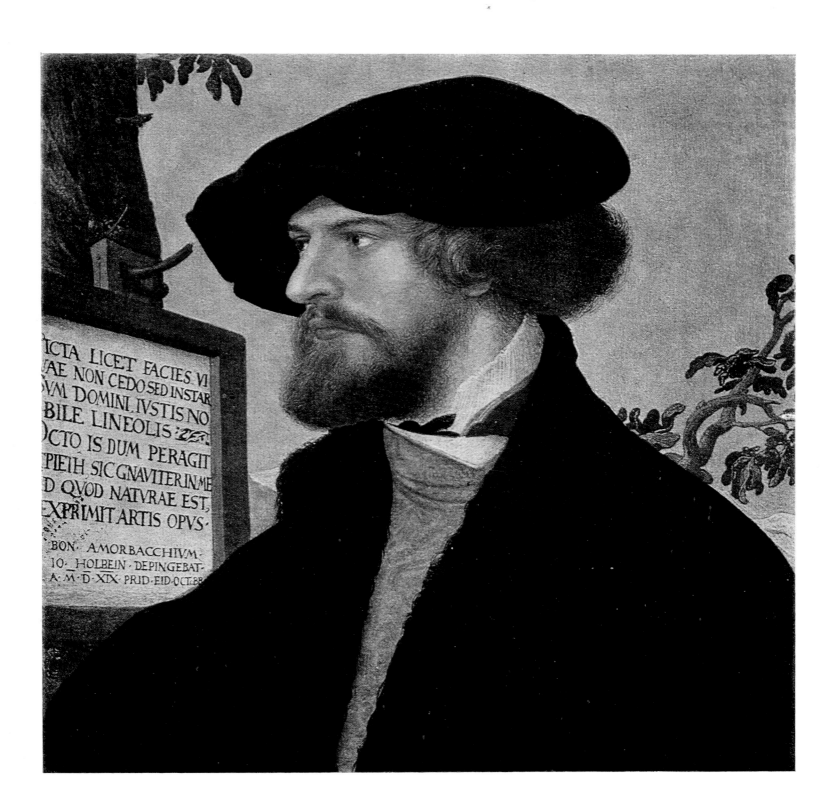

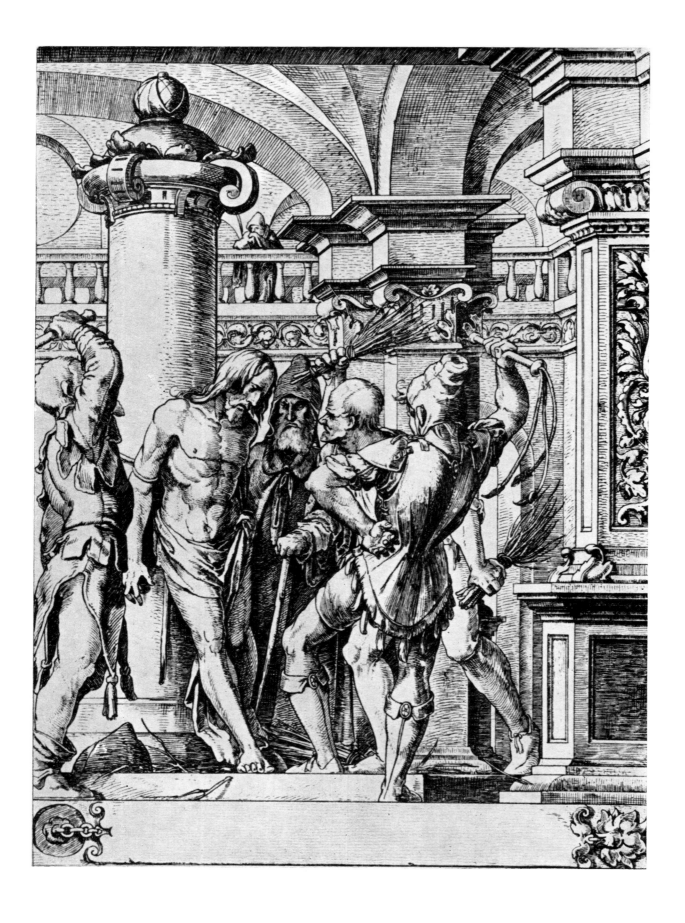

10. Passion of Christ, Engraving 3:
*Christ Abused by the Soldiers*

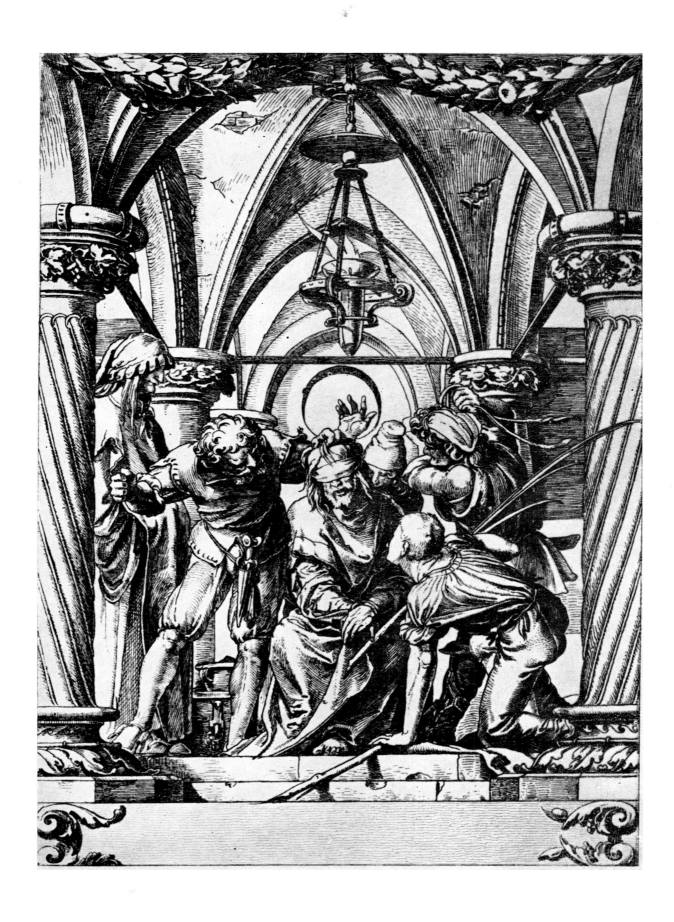

11. Passion of Christ, Engraving 4:
   *Christ Crowned with Thorns*

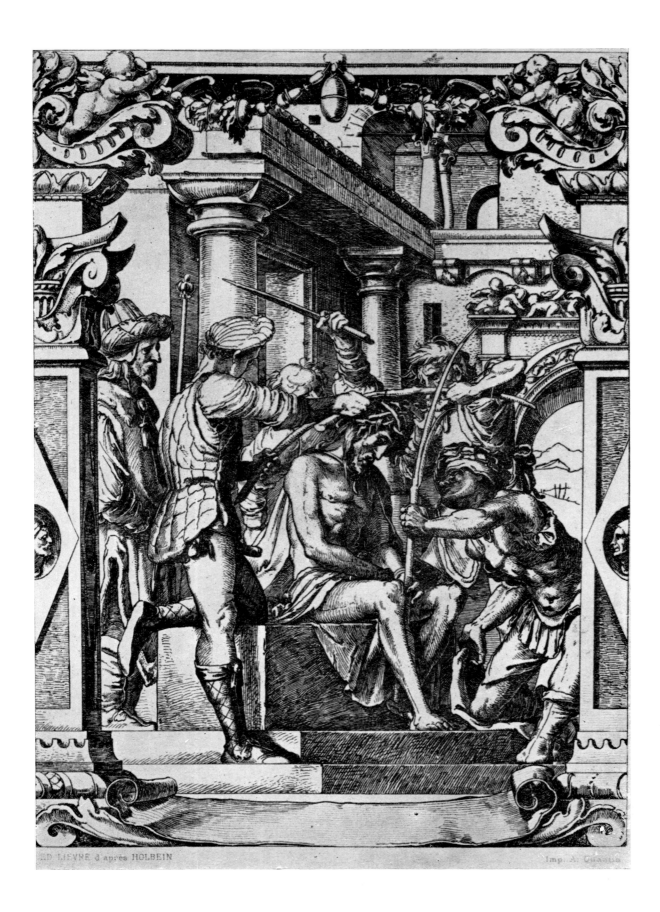

12. Passion of Christ, Engraving 7:
   *The Procession to Calvary*

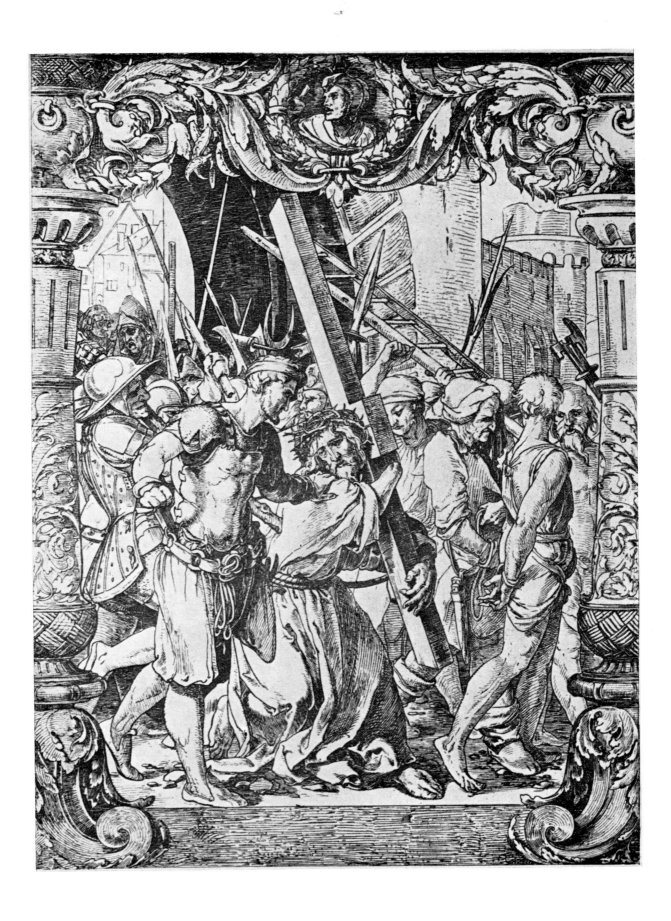

13. Passion of Christ, Engraving 10:
   *Christ between the Two Bandits*

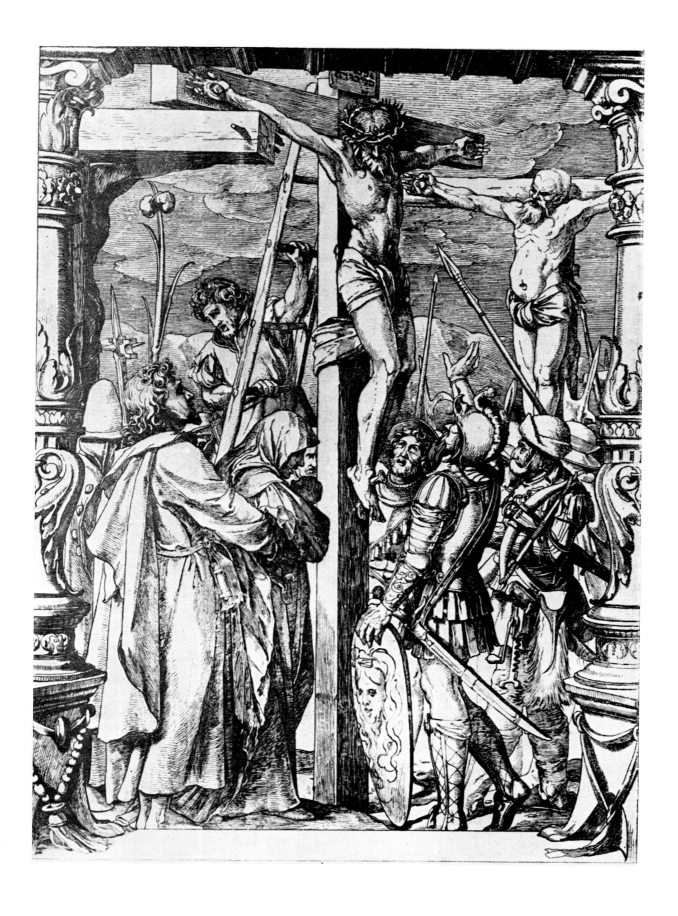

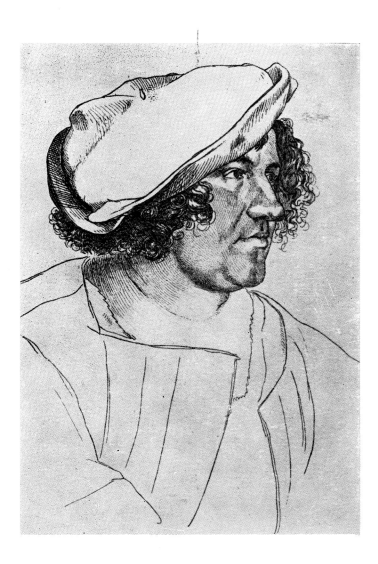

14. The **Burgomaster** Jakob Meyer zum Hasen

15. Dorothea Meyer Kannengiesser

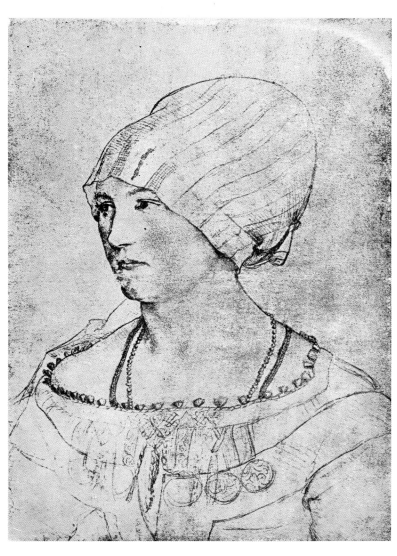

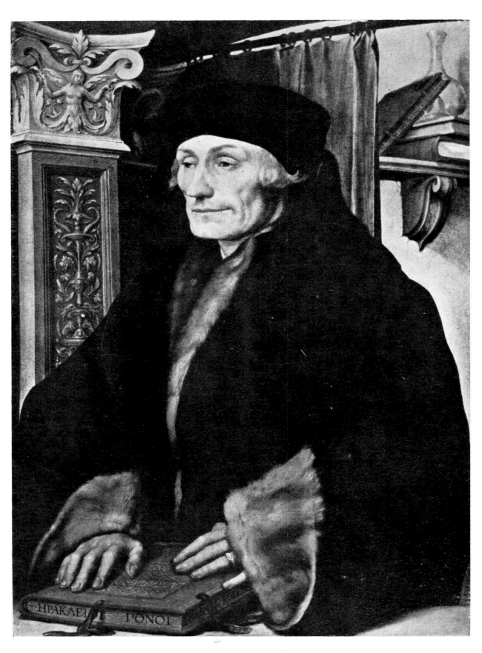

16. Erasmus of Rotterdam

17. Studies of Hands for Erasmus' Portrait

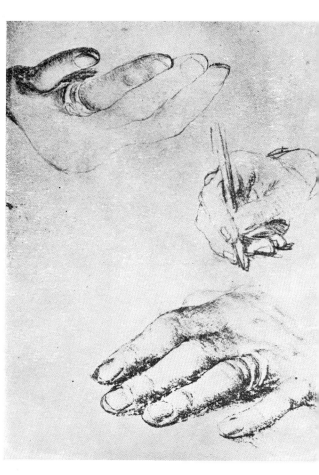

18. Erasmus of Rotterdam

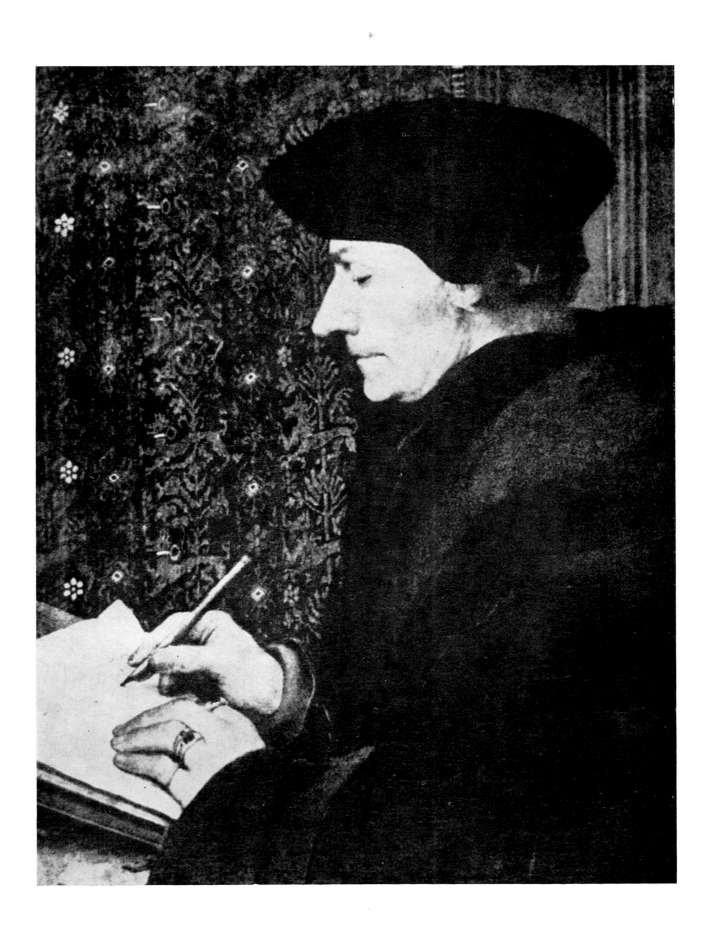

19. Study for the Solothurn Madonna
    (Presumed portrait of Artist's wife)

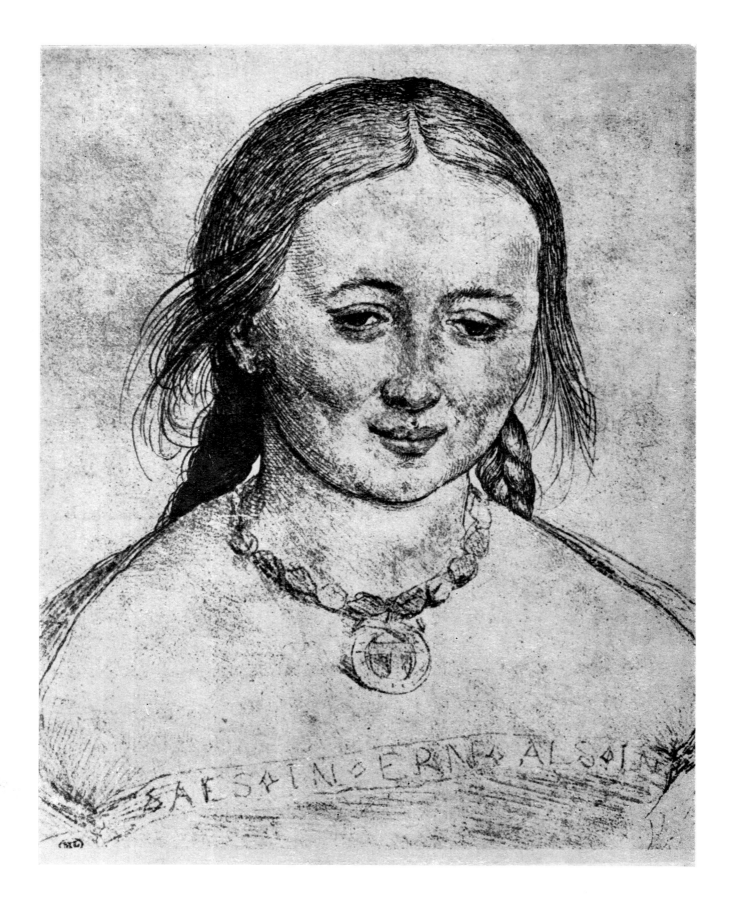

20. Portrait of John Zimmerman

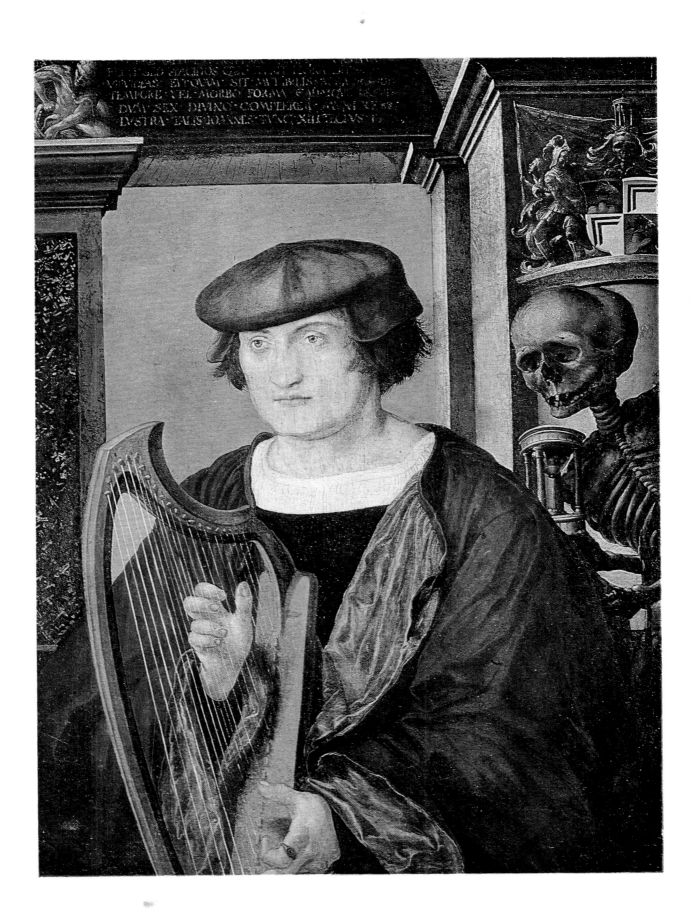

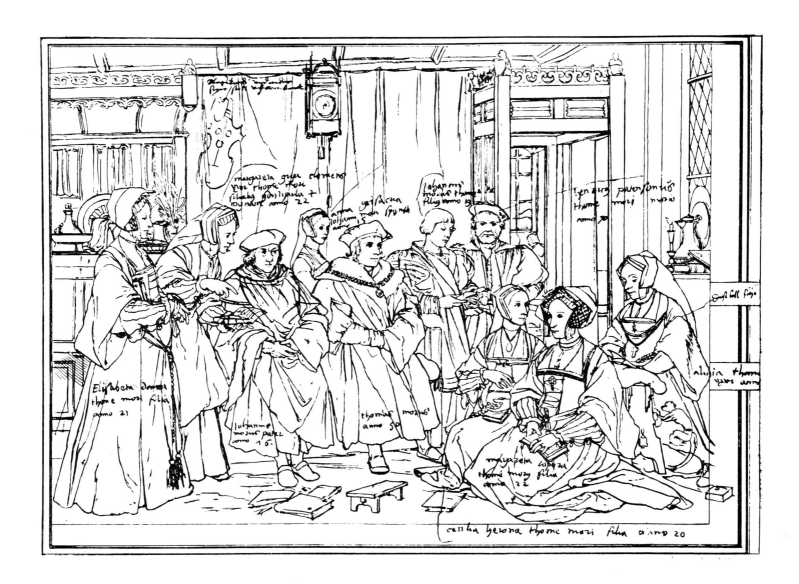

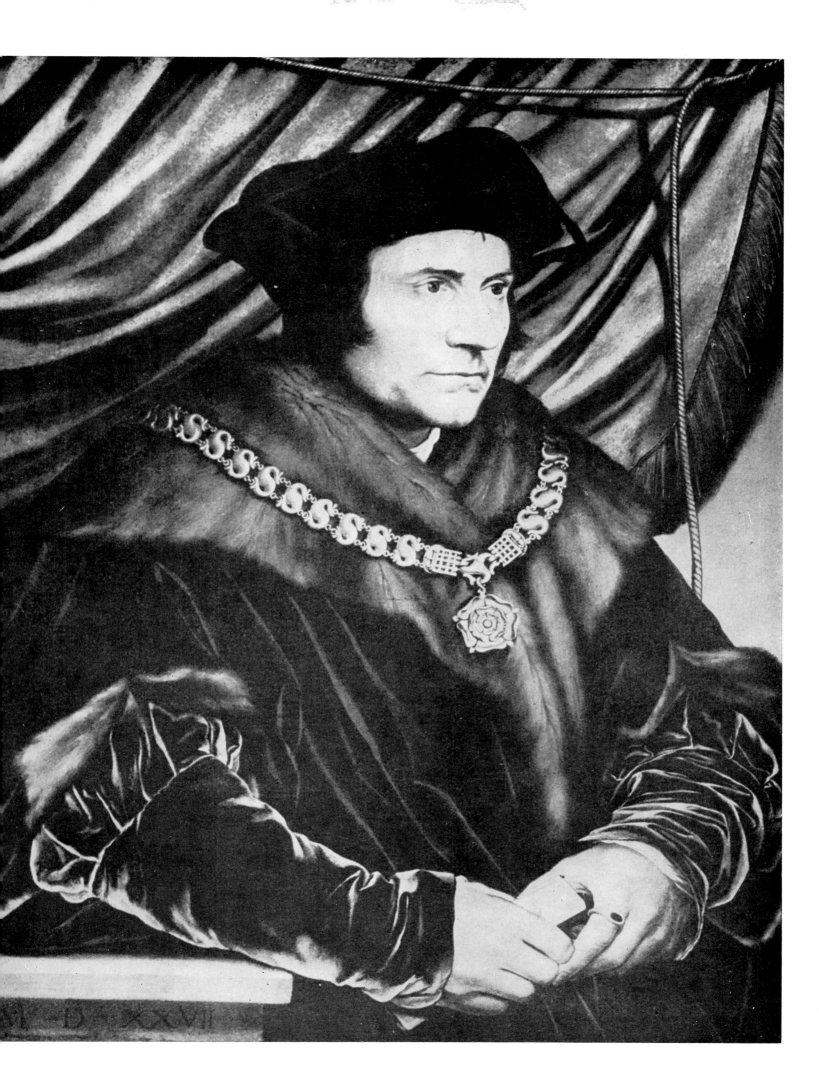

23. Cecily Heron, Younger Daughter of Sir Thomas More

24. John More the Younger

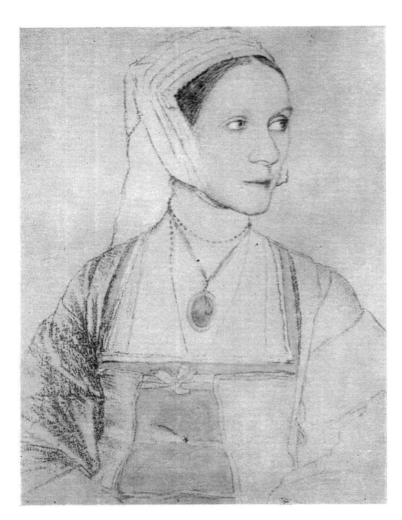

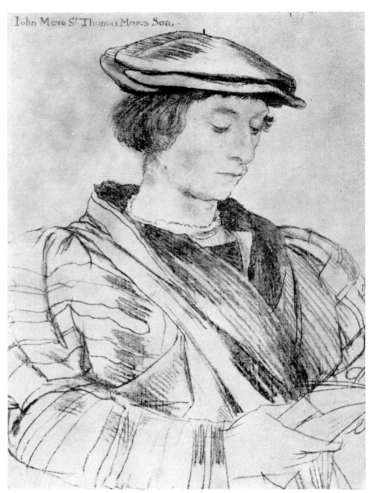

25. Sir John More, Father of Sir Thomas Morus

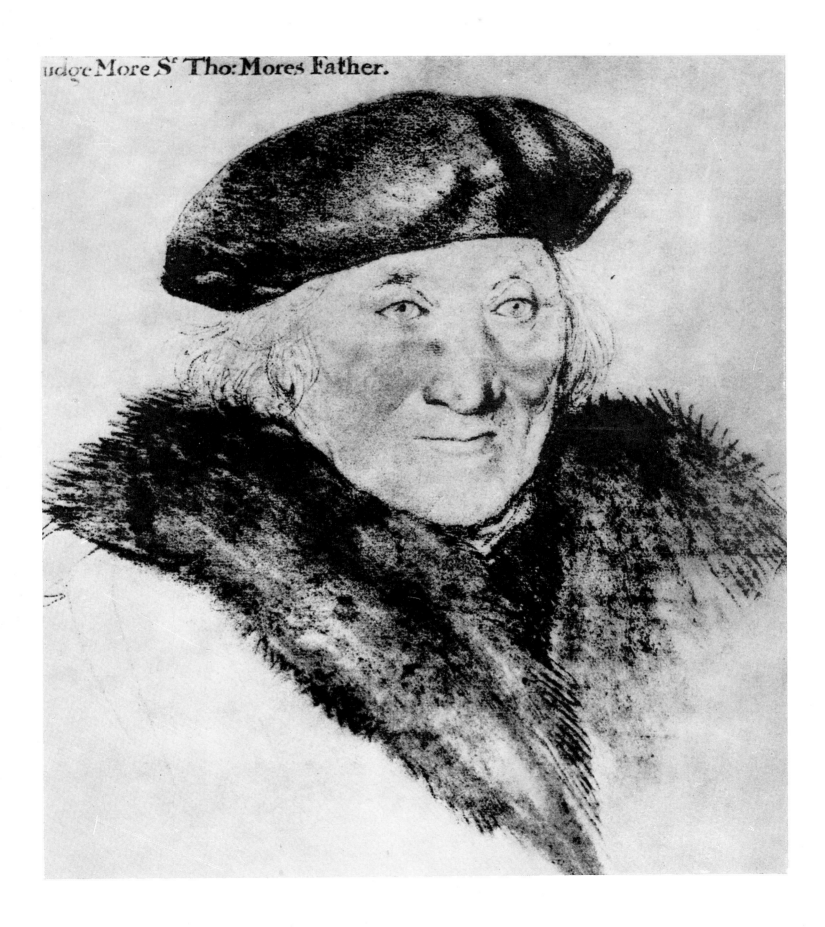

udge More Sr Tho: Mores Father.

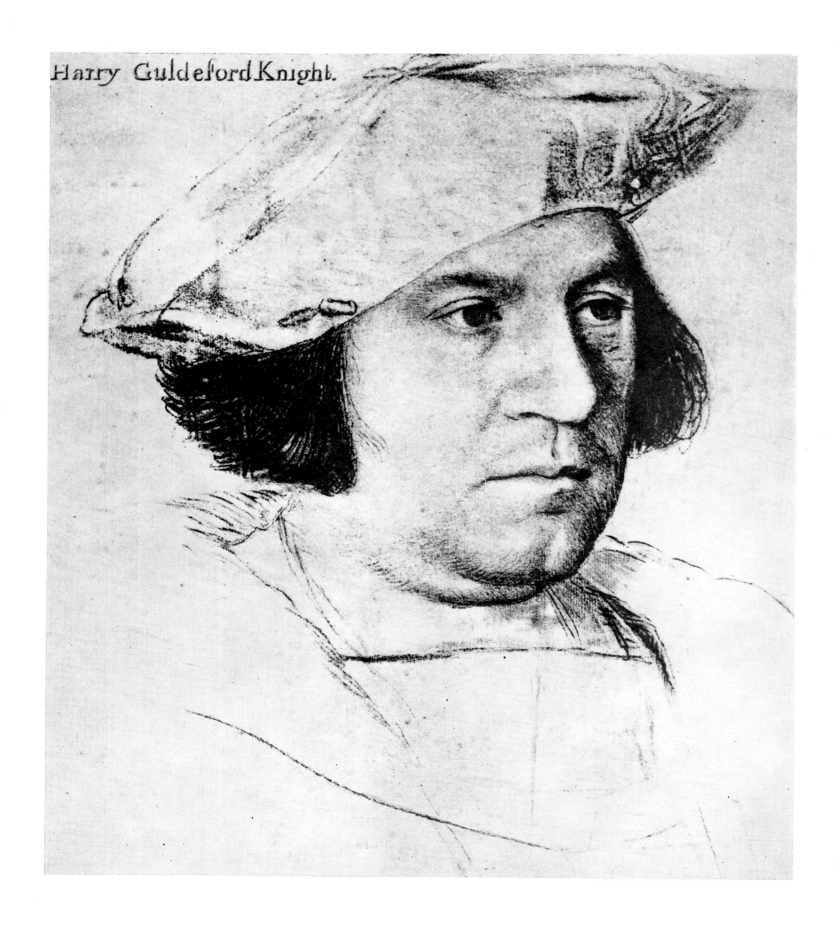

Harry Guldeford Knight.

27. William Warham, Archbishop of Canterbury

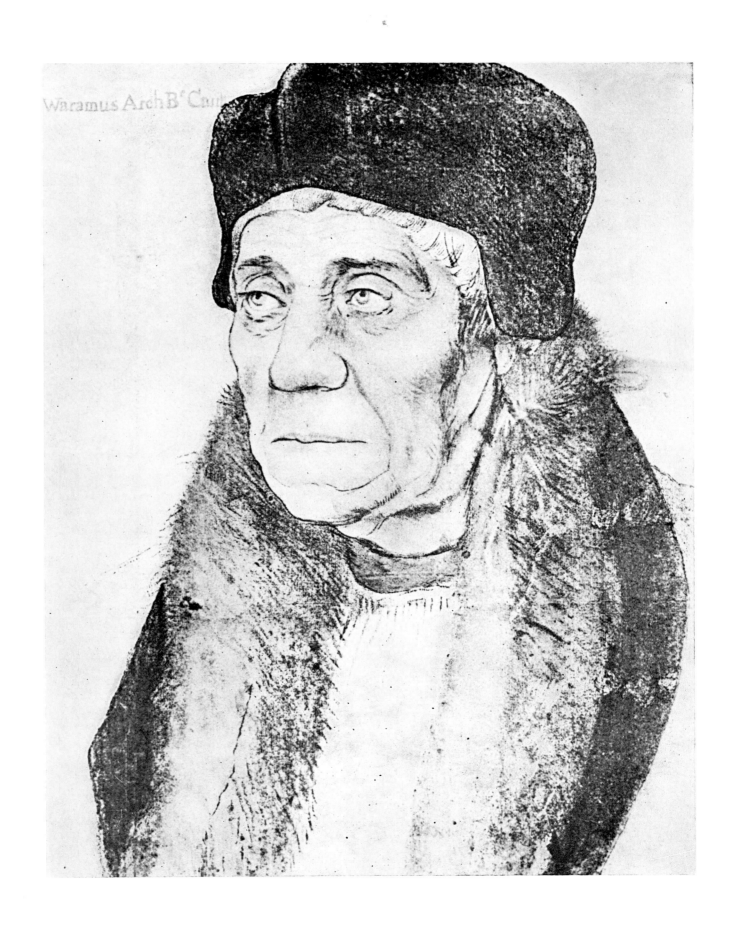

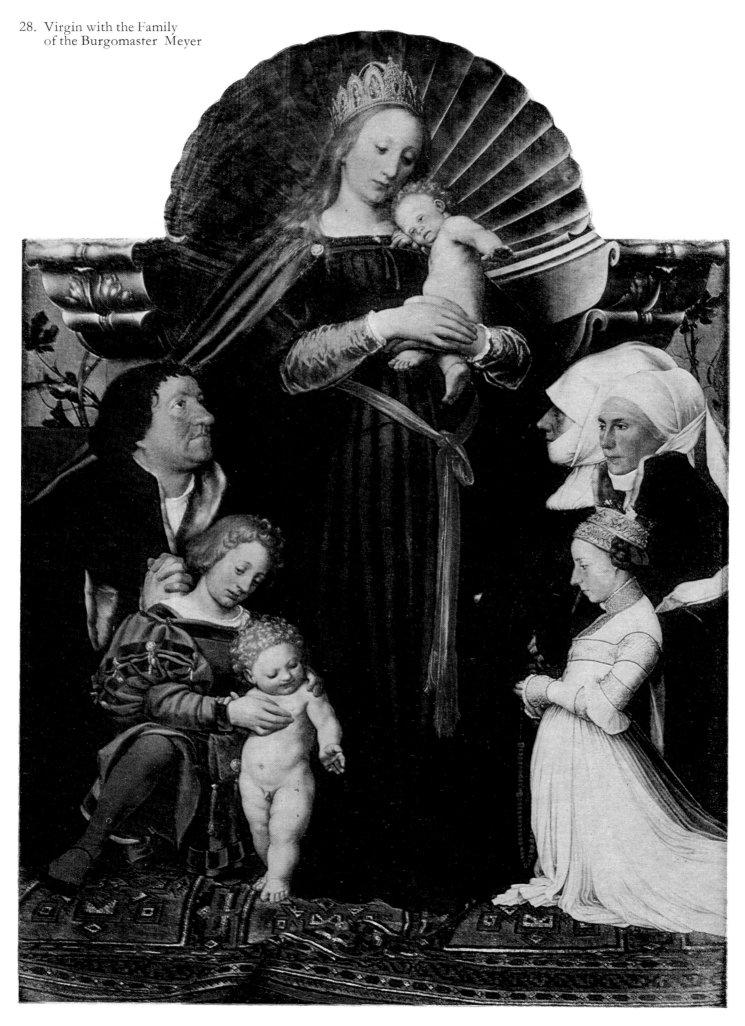

28. Virgin with the Family
of the Burgomaster Meyer

29. Laïs of Corinth (Portrait of Dorothea von Offenburg)

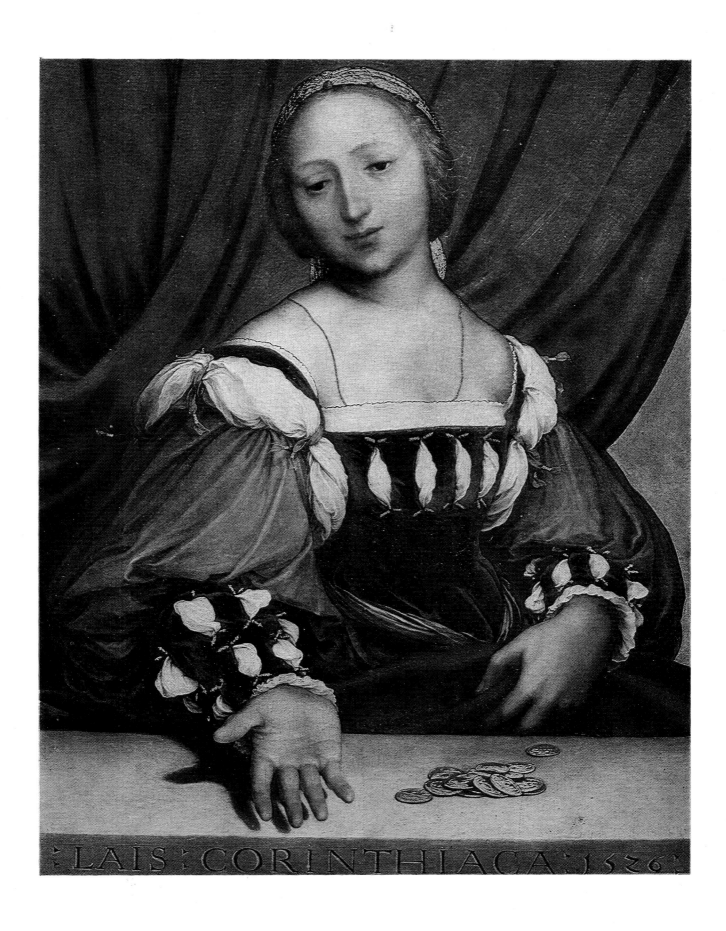

30. Mary, Lady Henegham (?)

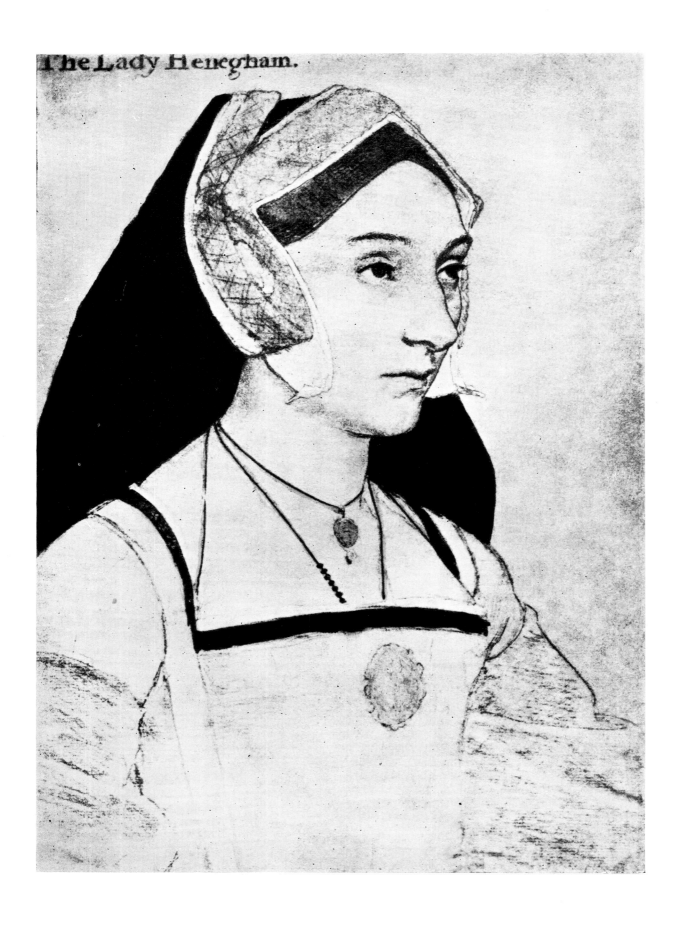

31. Sir Thomas Elyot

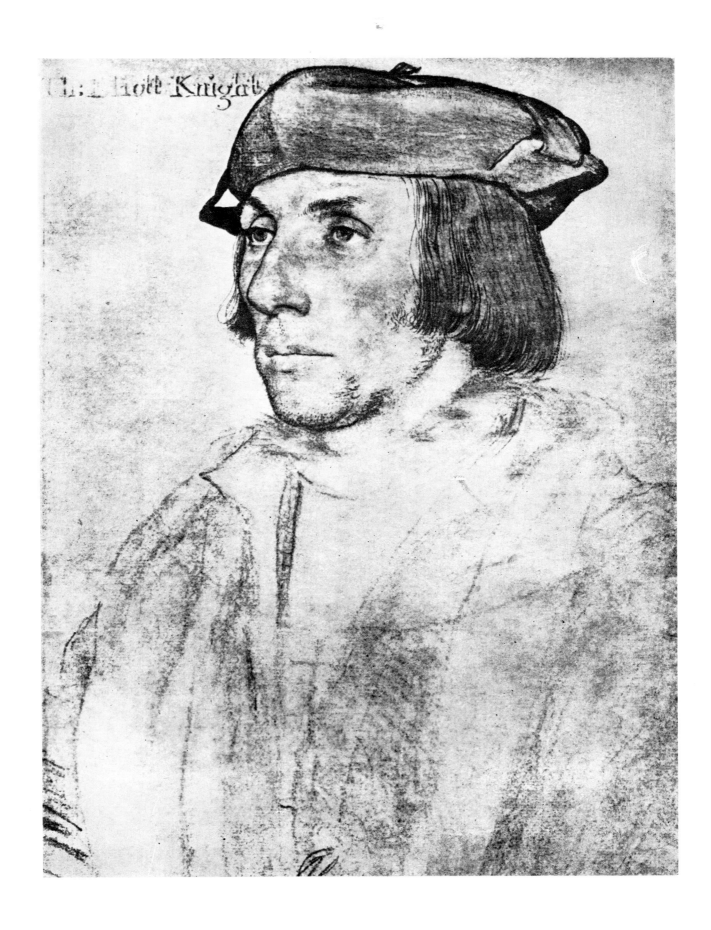

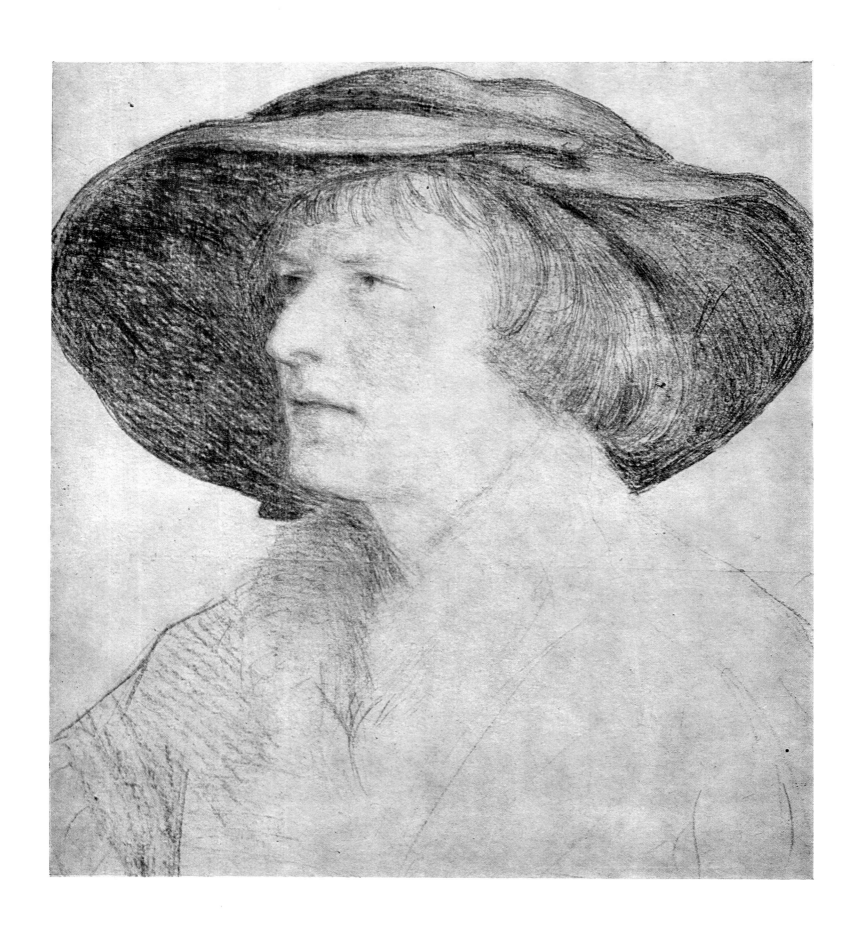

33. Robert Cheseman

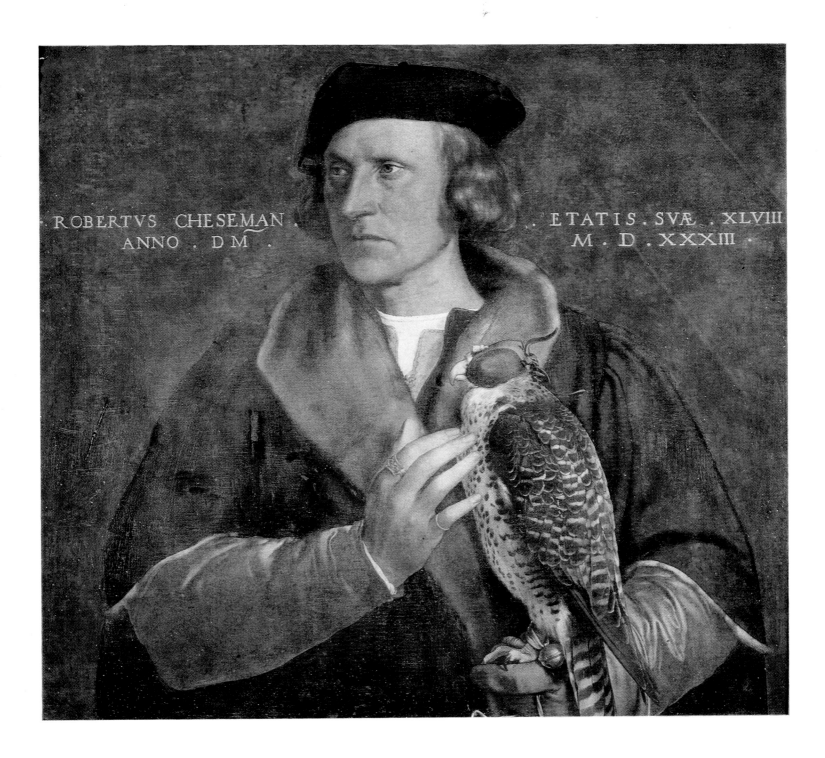

34. Sir Richard Southwell

35. Cardinal Fisher, Bishop of Rochester (?)

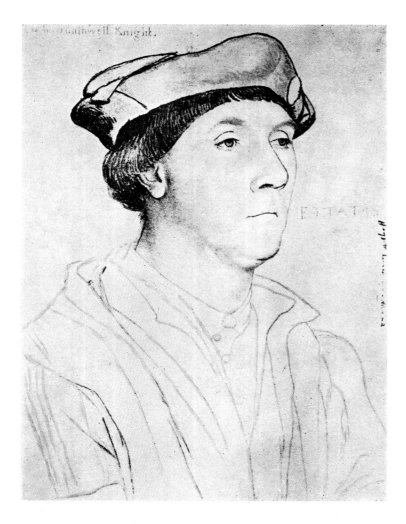

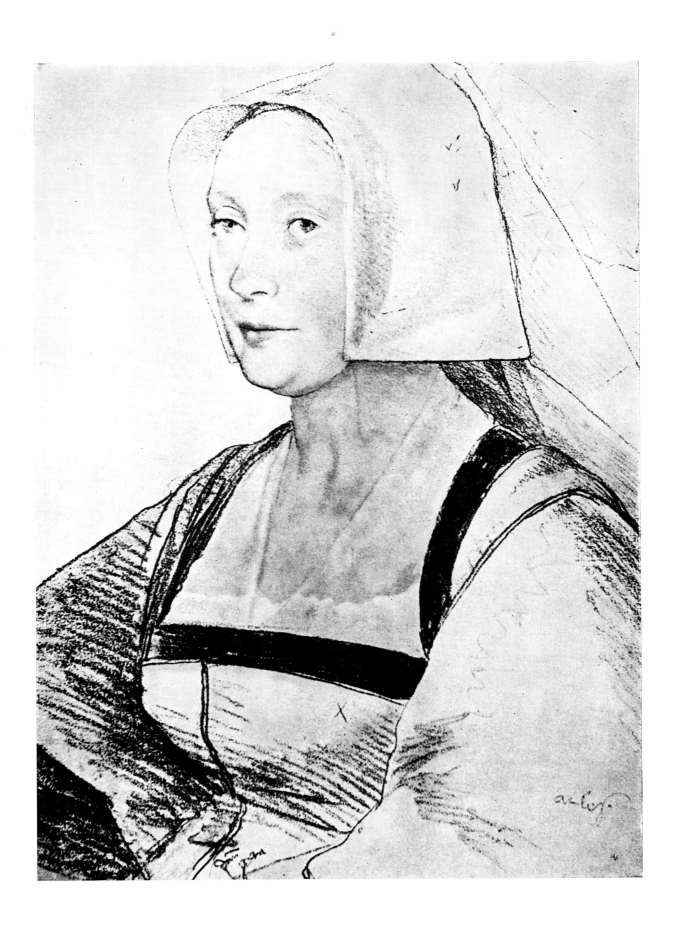

37. The Artist's Family

38. Nicholas Kratzer, Astronomer to King Henry VIII

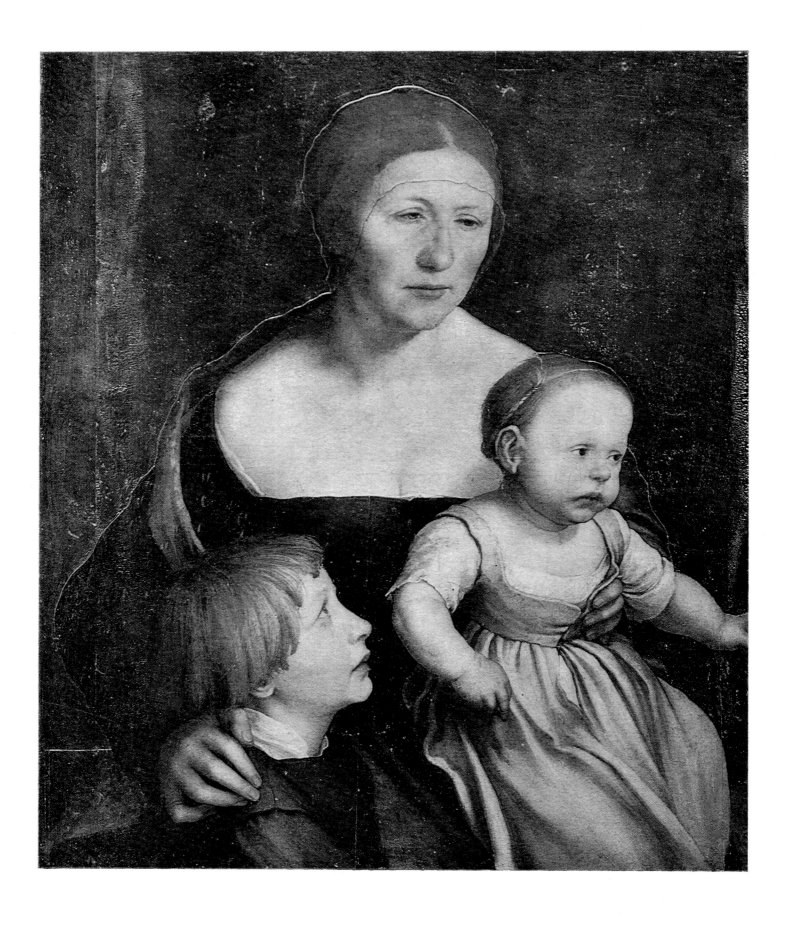

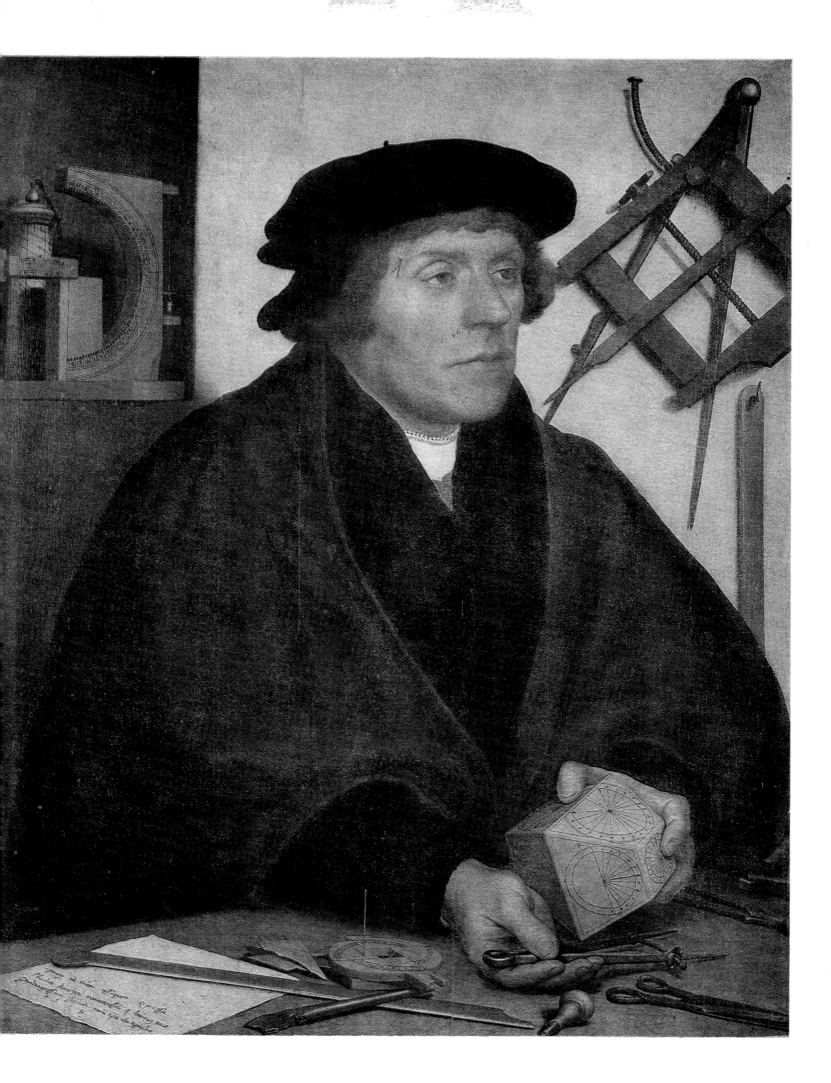

39. Lady Jane Lister

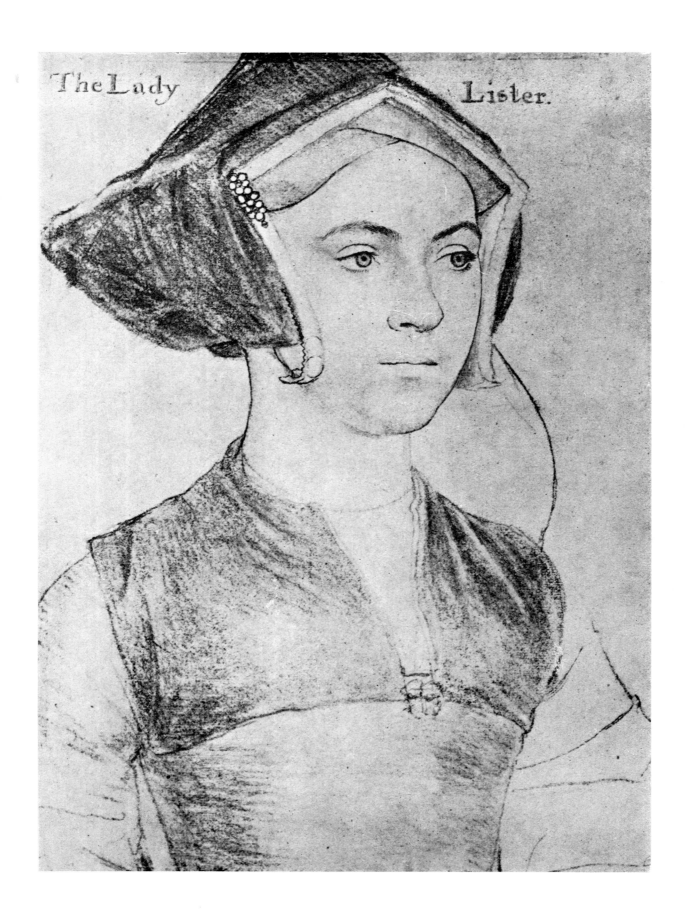

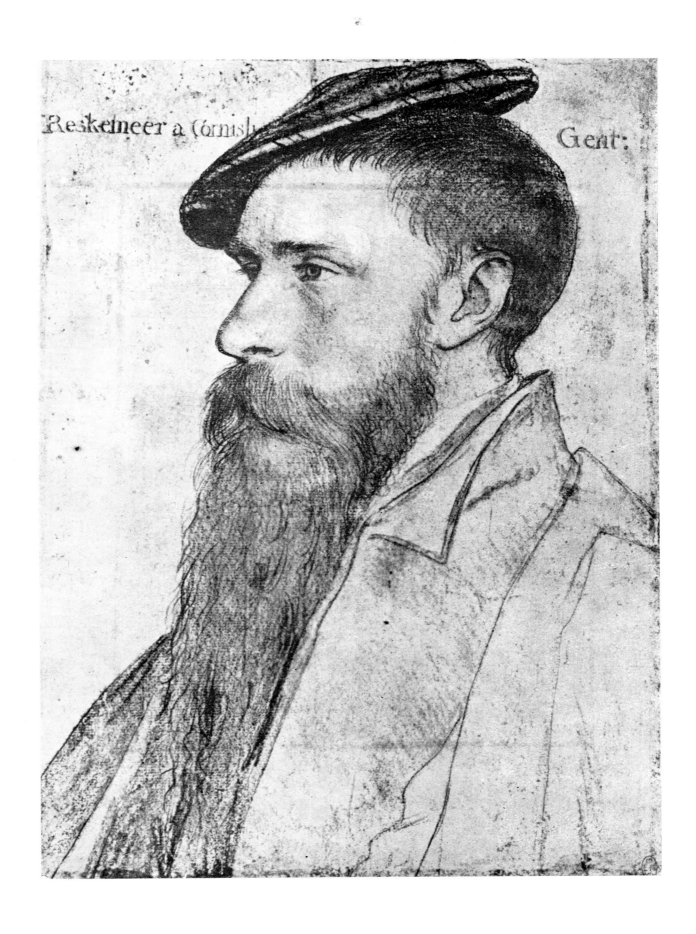

40. William Reskimer

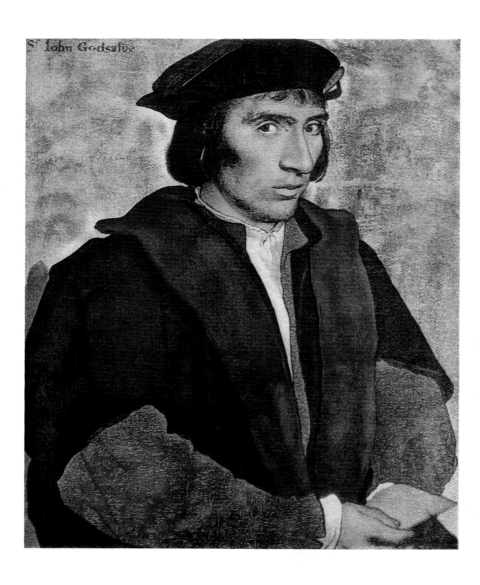

41. Sir John Godsalve

42. William Fitzwilliam, Earl of Southampton

43. Queen Jane Seymour

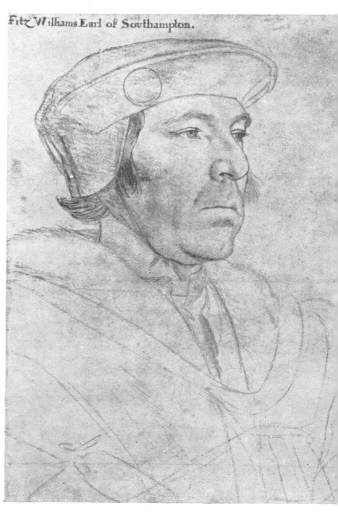

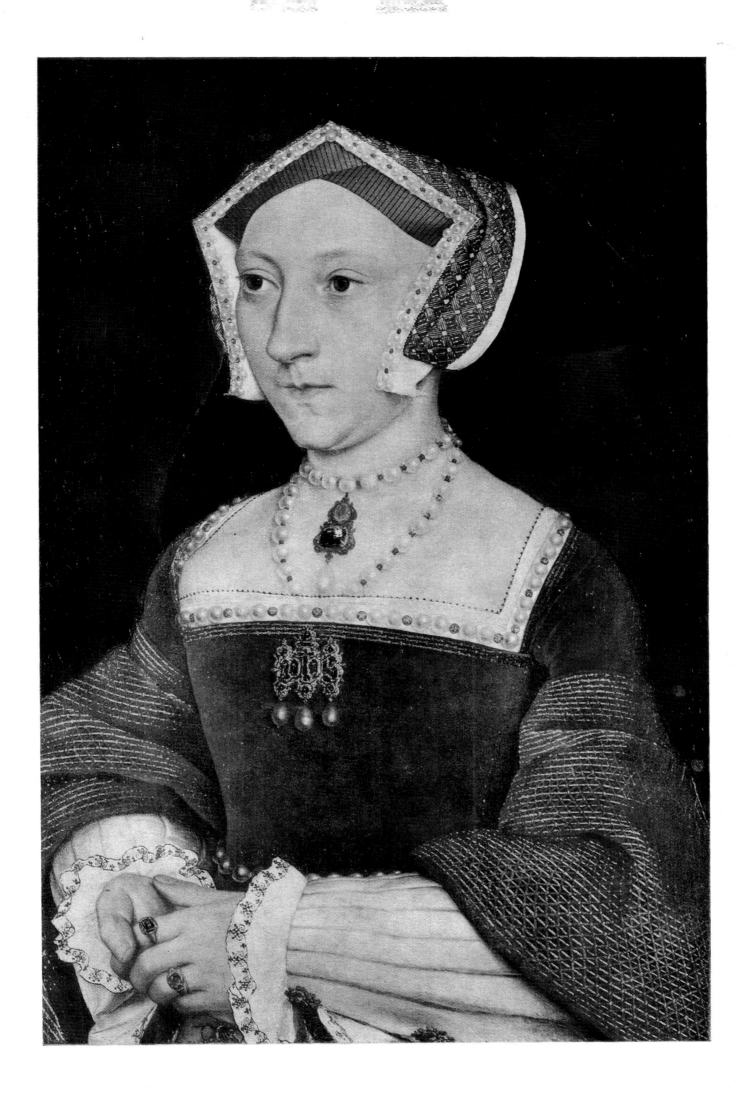

44. Unknown Woman (Queen Anne Boleyn?)

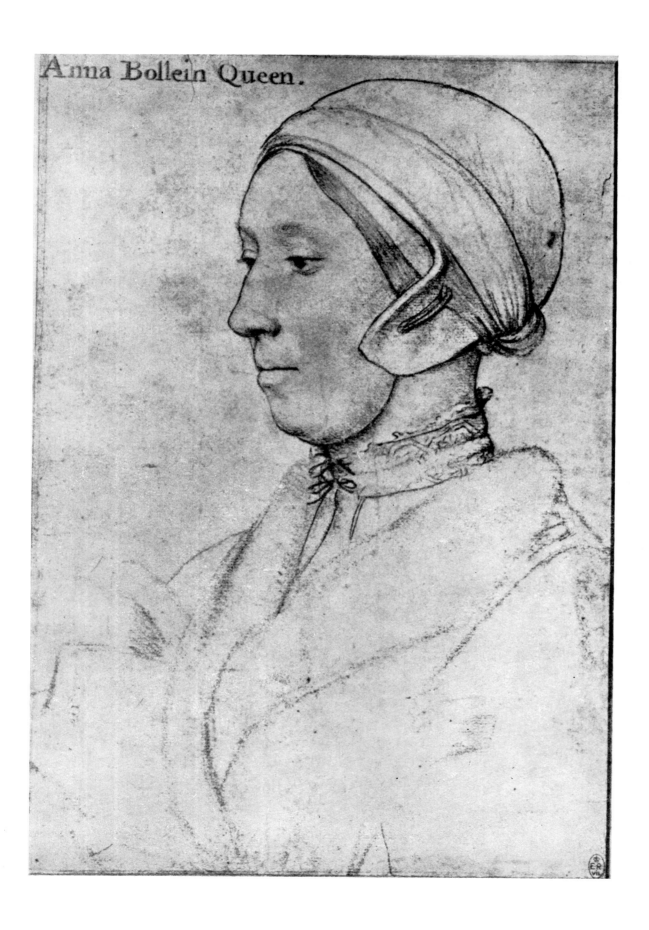

45. Lady Margaret Elyot

46. Lady Joan Meutas

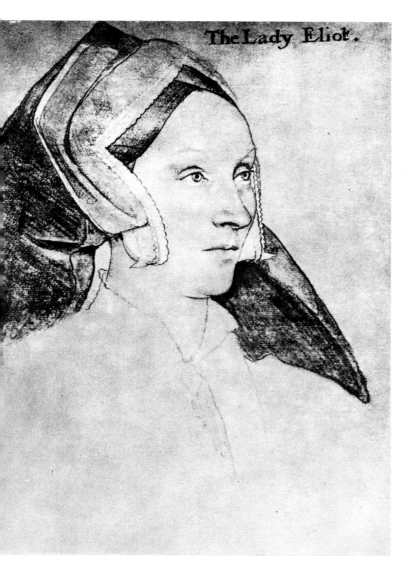

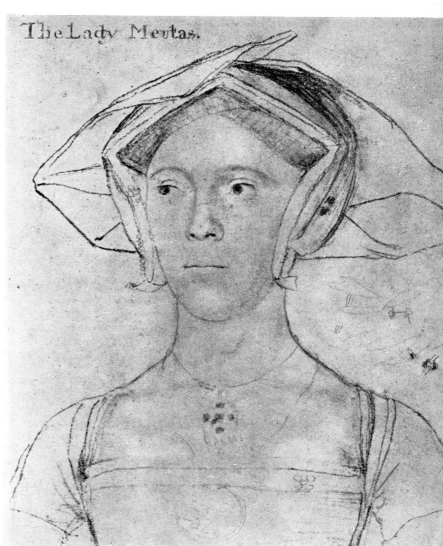

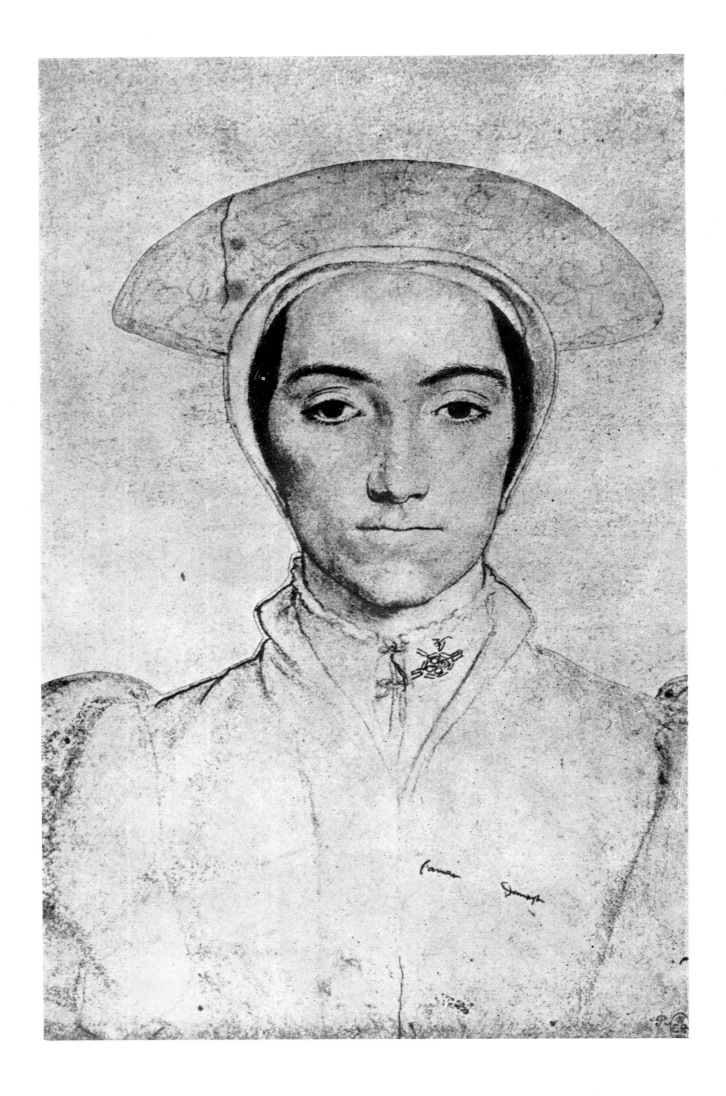

47. Portrait of a Woman

48. Georg Gisze, a German Merchant in London

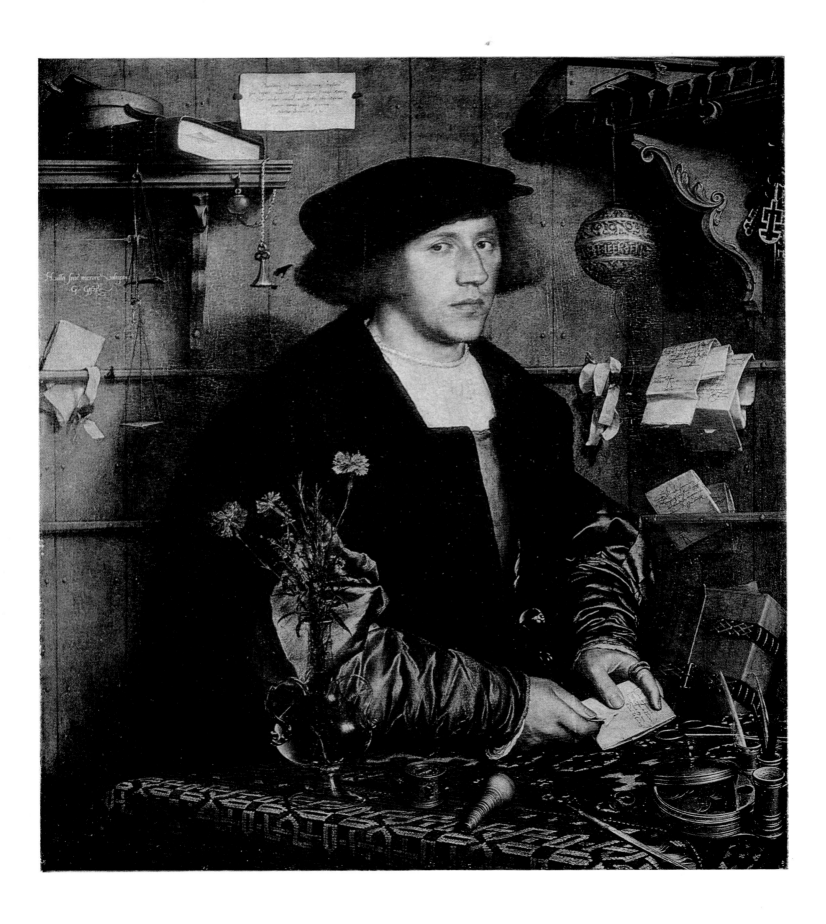

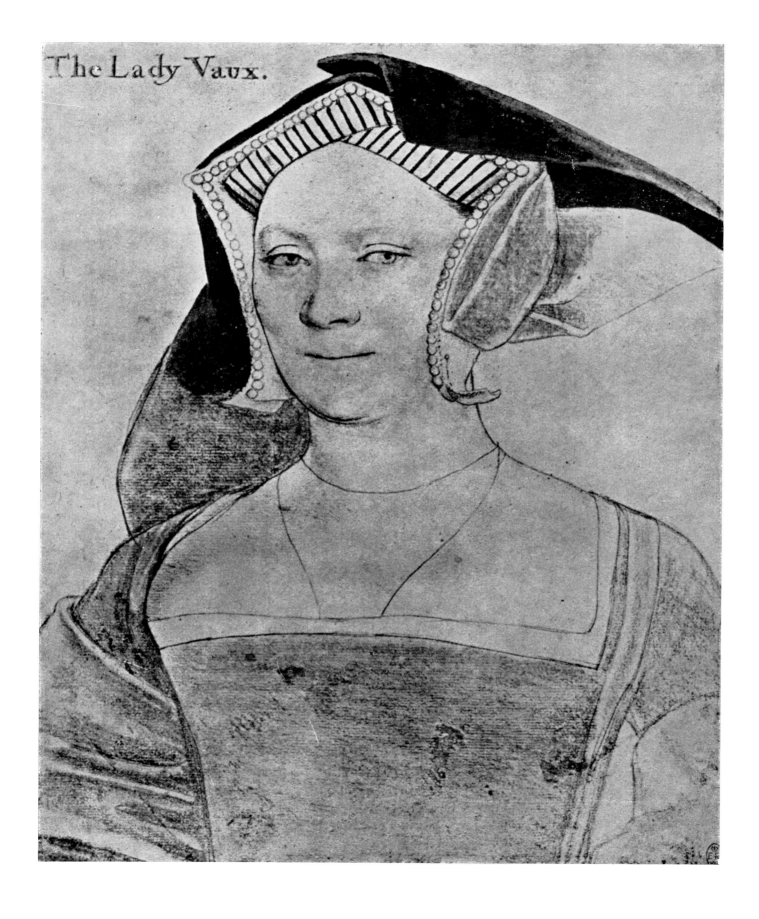

50. Simon George of Cornwall

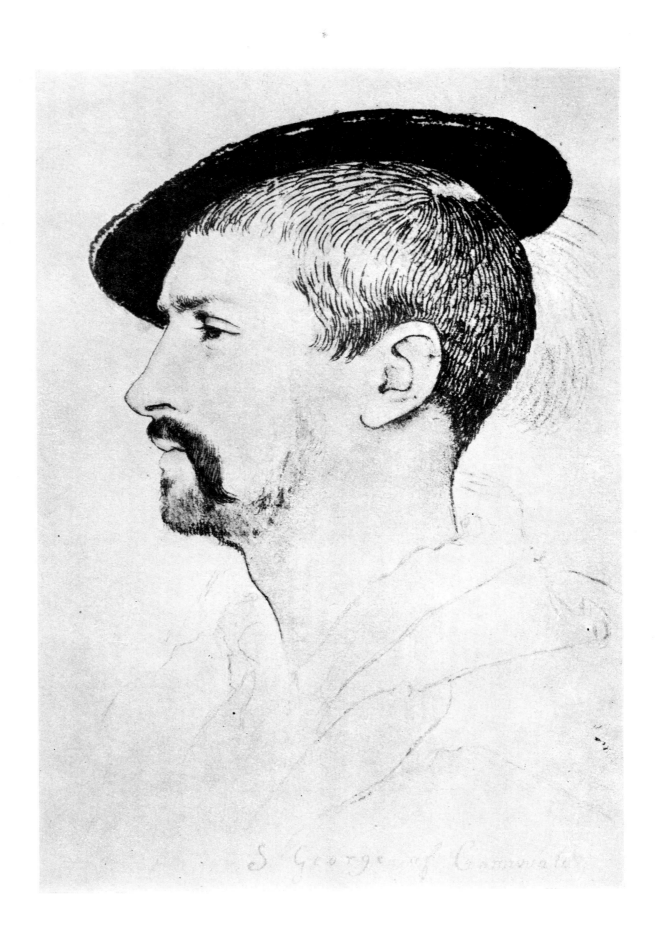

51. The Ambassadors

52. The Ambassadors, *detail*

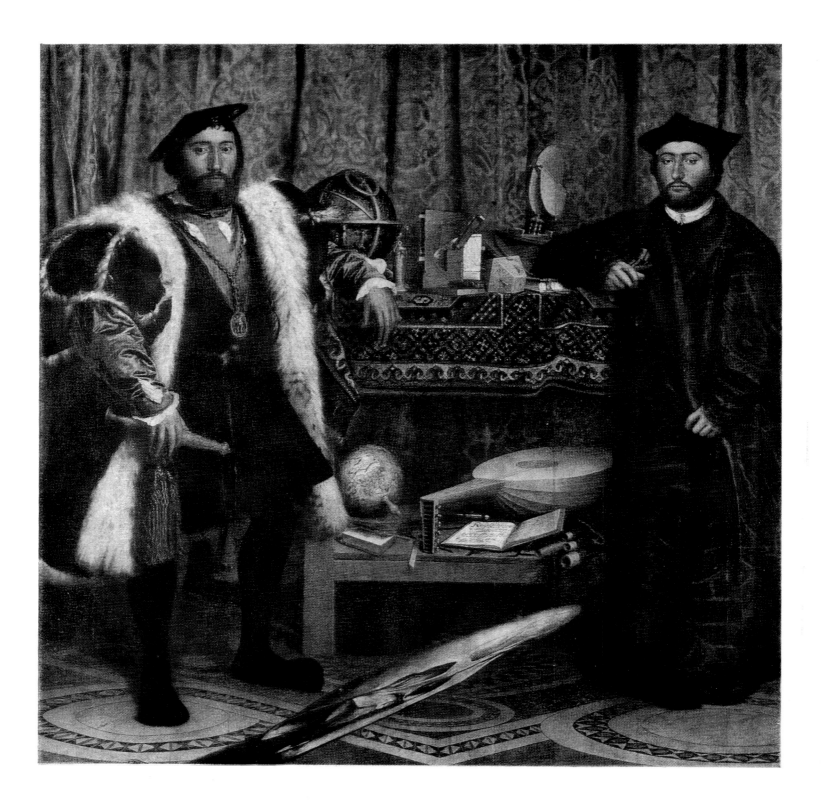

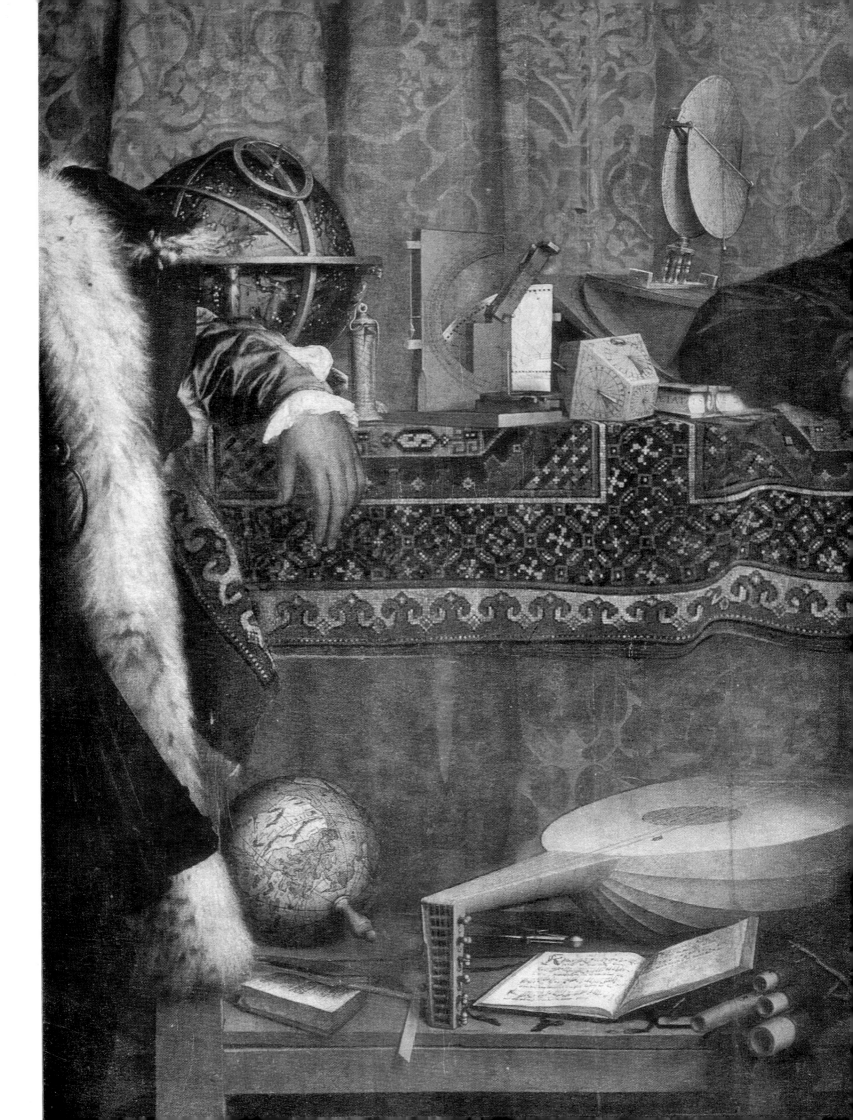

ÆTATIS · SVÆ · 54

53. Portrait of a Man

54. John Russell, Earl of Bedford

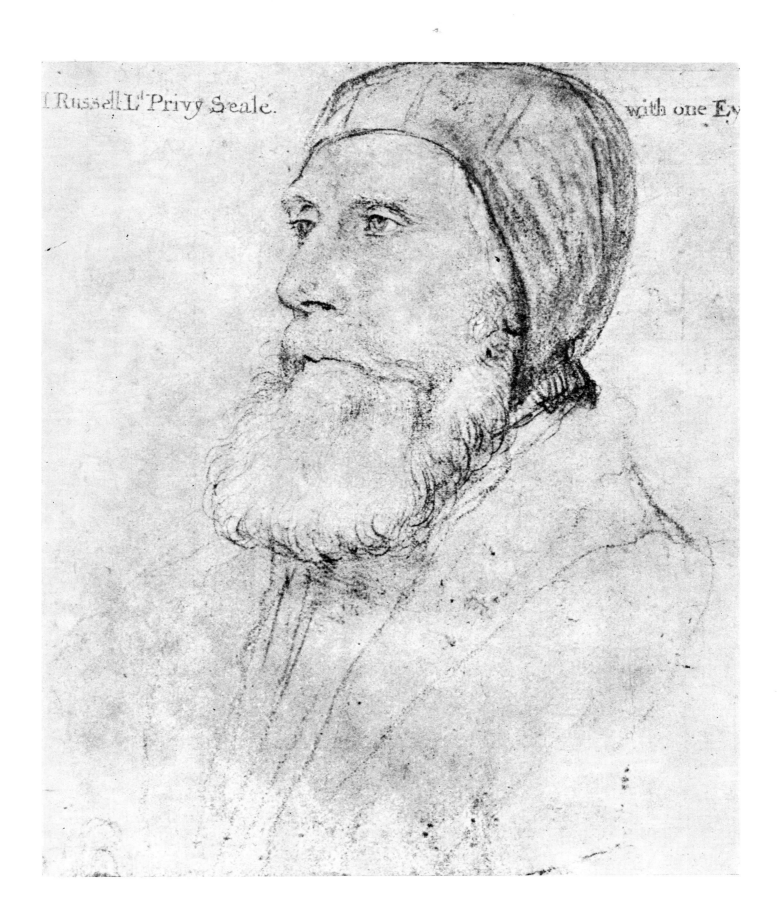

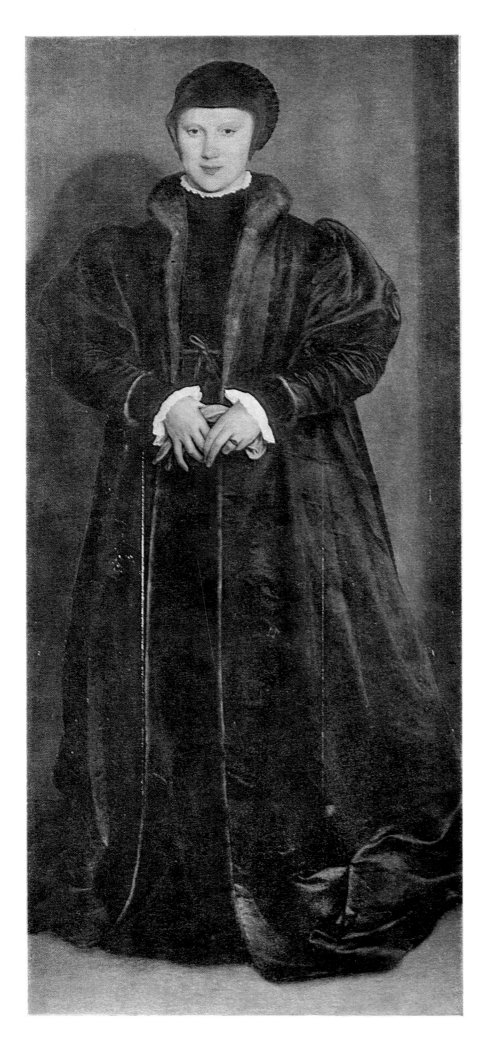

55. Christina of Denmark, Duchess of Milan

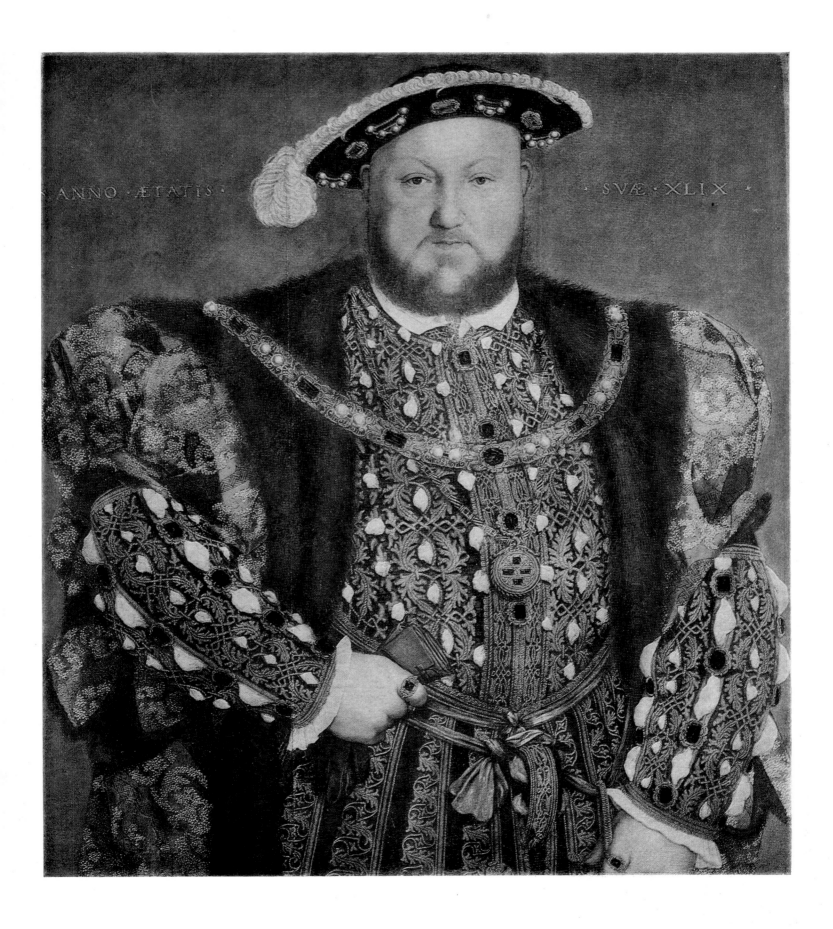

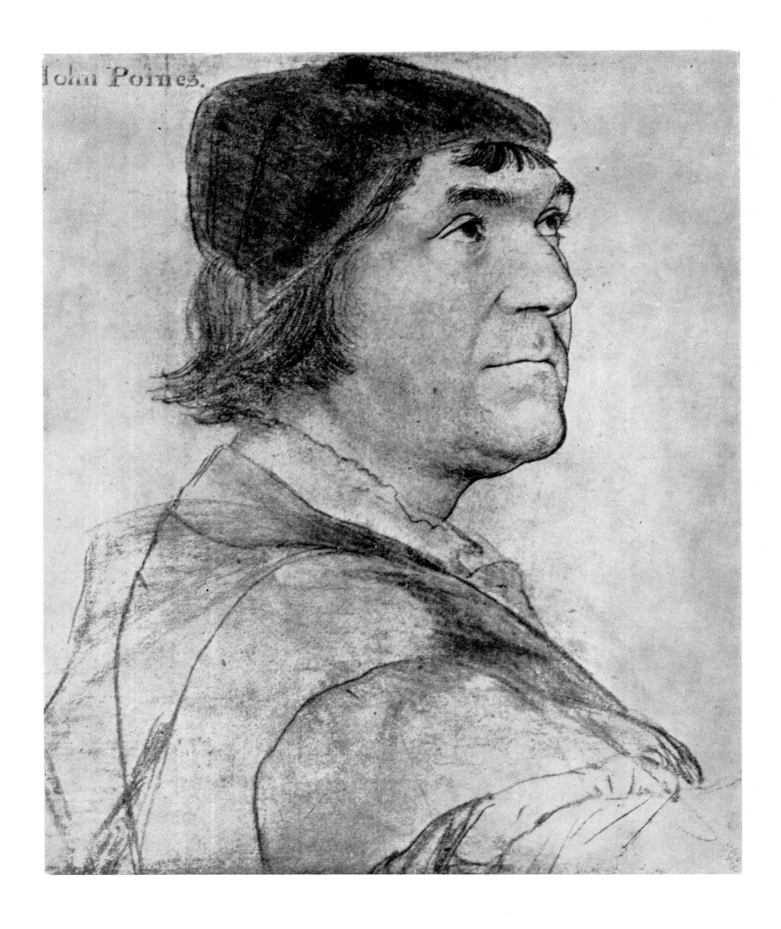

58. Portrait of a Woman

59. Portrait of a Man

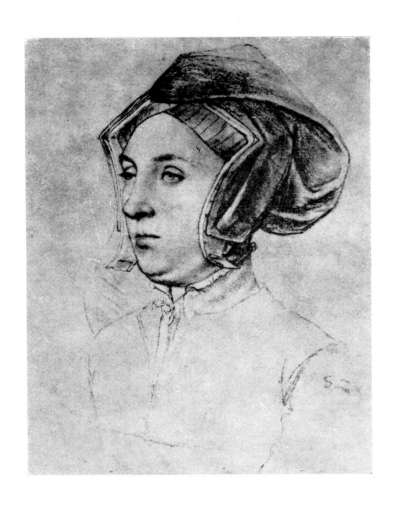

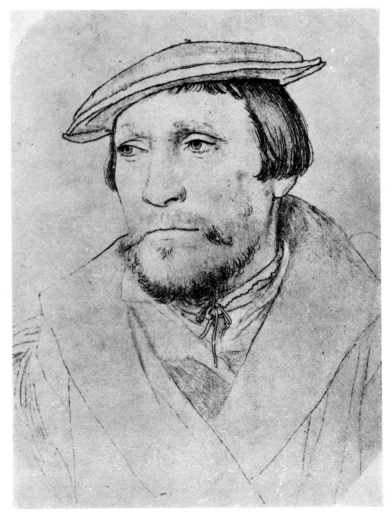

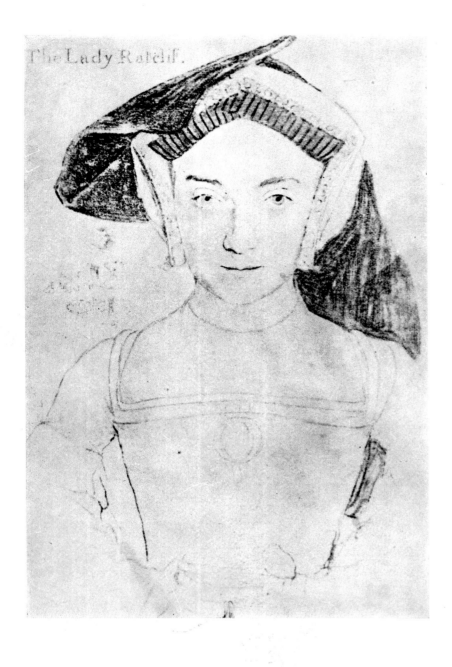

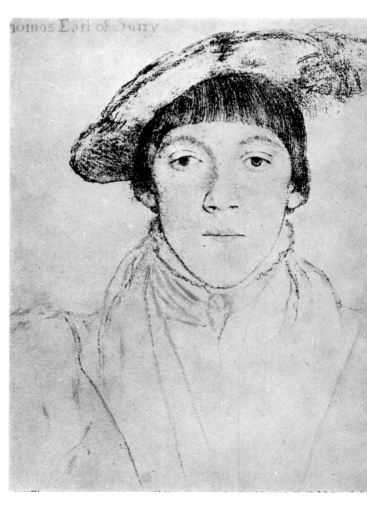

60. Lady Ratcliffe

61. Henry Howard, Earl of Surrey

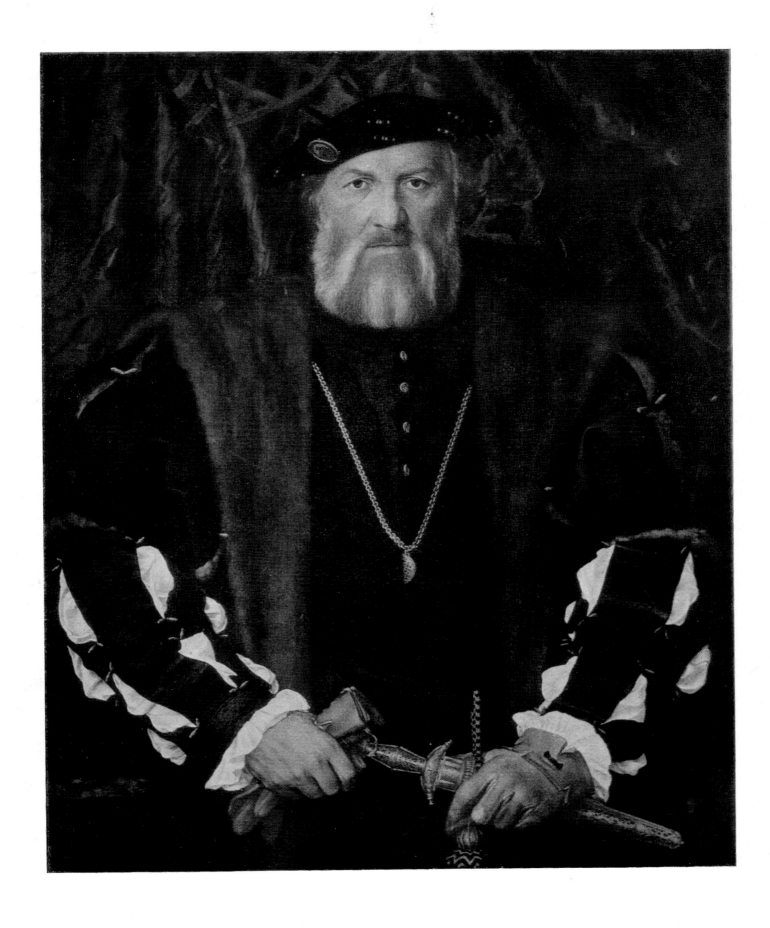

63. Jean de Dinteville (?)

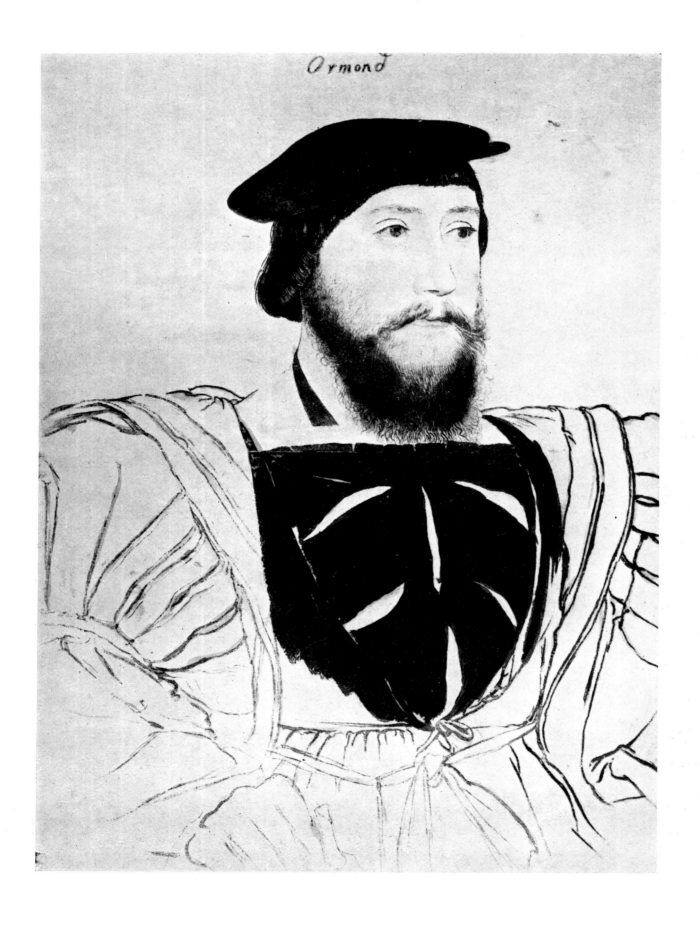

64. ANONYMOUS (Hans Holbein School): *Henry VIII*

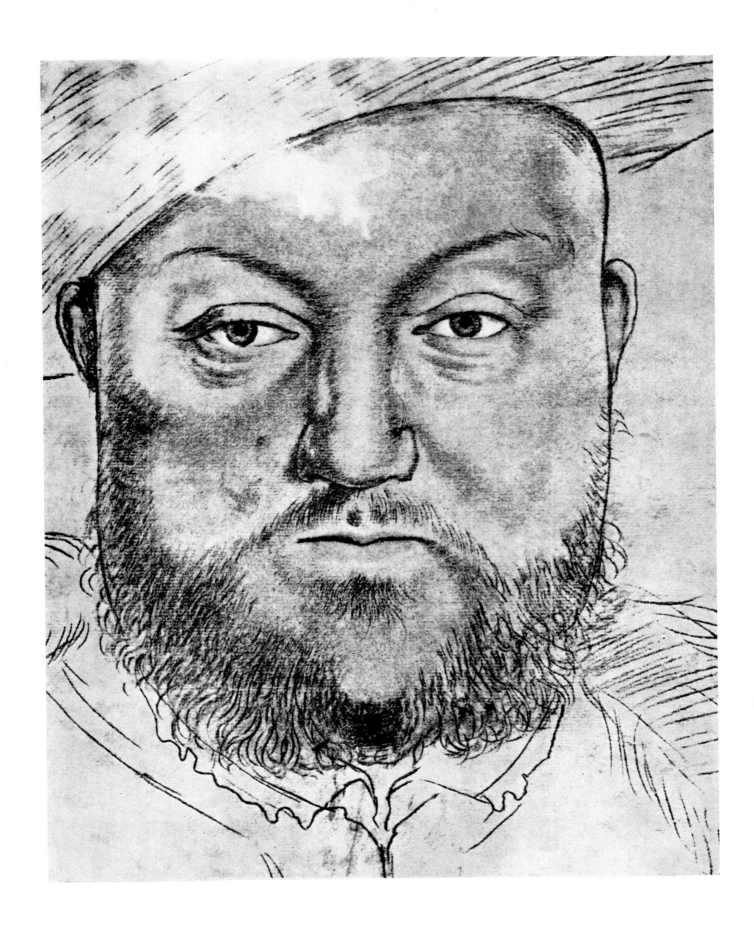

MERIDIANE PUBLISHING HOUSE
BUCHAREST
PRINTED IN ROMANIA